IMAGES
of Modern America

AKRON

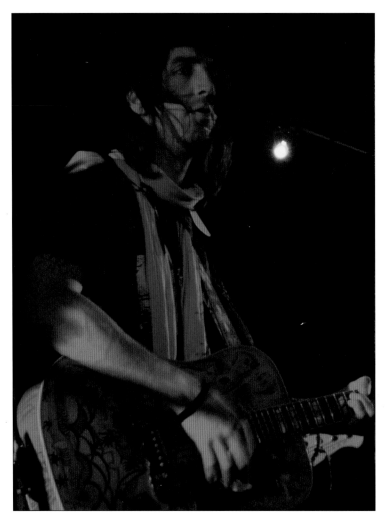

Since the R&B group Ruby & the Romantics had a number of hits in the early 1960s to acts today like The Black Keys, If These Trees Could Talk, "Ripper" Owens, and Joseph Arthur, Akron and music have been intertwined. Many Akron fans enjoy their nights at Musica, where Arthur performs here in 2008, and its neighbor and premiere Jazz club in Akron, Blue Jazz. (Photograph by Shan Spyker/ Sisters Dissonance.)

ON THE FRONT COVER: Clockwise from the top left, Akron rock icons Devo in downtown in the 1970s (photograph by Janet Mocaska); Congressman, environmentalist, and Firestone scion John Seiberling taking a photograph in one of Akron's parks (courtesy of the John F. Seiberling collection); fireworks at the Inventure Place and Inventors Hall of Fame grand opening in 1995 (photograph by Bruce Ford); three-time world speed record holder Art Arfons at his Akron shop in the 1970s (photograph by Ott Gangl); NASA astronaut Judith Resnik, who lost her life in the 1986 *Challenger* disaster (photograph by Bruce Ford).

ON THE BACK COVER: From left to right, the Everett Covered Bridge, the only remaining covered bridge in Summit County and one of the top 10 places for photography on public lands according to the National Part Foundation (photograph by Lew Stamp); Akron Aeros mascot Orbit and fan in during the Aeros' inaugural season (photograph by Ed Suba); the *Akron* sitting in its hangar in the late 1980s (photograph by Robin Witek).

IMAGES
of Modern America

AKRON

Calvin Rydbom

ARCADIA
PUBLISHING

Copyright © 2015 by Calvin Rydbom
ISBN 978-1-4671-1528-5

Published by Arcadia Publishing
Charleston, South Carolina

Printed in the United States of America

Library of Congress Control Number: 2015945201

For all general information, please contact Arcadia Publishing:
Telephone 843-853-2070
Fax 843-853-0044
E-mail sales@arcadiapublishing.com
For customer service and orders:
Toll-Free 1-888-313-2665

Visit us on the Internet at www.arcadiapublishing.com

CONTENTS

ACKNOWLEDGMENTS

I went into this project fairly sure of myself; it was not my first book or even my second. And if you look around, you will find few websites commemorating some aspect of what we usually think of as history.

But they were easy compared to this book. It seems people do not find their day-to-day lives particularly historical. So, when you go around looking for images of the longtime deli or store that was on the corner until 1992, people seem perplexed. Why would they have taken photograph of the place they went to for cheesecake? That is not history.

The thing is, those photographs are just as historical as one from 1860. They still tell the story of the people who were there. It made it difficult, and frankly there are a few images I simply never found for places that meant something to me in 1986, which of course meant I assumed it was important to everyone living in Akron and Summit County in 1986.

I would not have been able to write this book without the help of more people than I could possibly list. But those I should list are Bruce Ford, who as the official photographer for the City of Akron was a huge help and asset; Jimi Imij, whose archives and knowledge of Akron and the Akron music scene seemed always at my disposal; and John Phillips, who one day about 55 years ago walked around downtown Akron snapping photographs and was more than happy to let me use them. My editor at Arcadia Publishing, Liz Gurley, gave constant encouragement and thanked me for being one of those authors who constantly kept her up to date on my progress—although I am a tad suspicious about how glad she was to get five or six emails from me some days.

Lastly, I would like to thank my two office mates at Pursue Posterity: Keith Peppers and Thomas Kubat. I missed working with Thomas on this book, as he had cowritten the last two with me, but he was very busy with some other projects at the office to do more than encourage this time around. This left no one to give me a somewhat annoyed grimace when I played fast and loose with the rules of grammar.

6

INTRODUCTION

If any city deserves to have its modern history discussed it is Akron, Ohio. The story of Akron can easily be broken into different eras, and the odd thing is we still tend to think of ourselves in terms of the old story, of old Akron. Ask someone what the nickname of Akron is and they will tell you it is the "Rubber Capital of the World," or the "Rubber City." While Goodyear still maintains its corporate headquarters in Akron and Firestone still has a large presence in the community, rubber, at least in its traditional form, is hardly the focus of Akron anymore. Between 2000 and 2007, the numbers of rubber workers in Akron was cut in half. No longer was a boy's goal to get a good job at Goodyear, Goodrich, Firestone, or General Tire and spend the rest of his life making tires.

No, the place that won the All-American City award in 1981, 1995, and 2008 bills itself as the "City of Invention" now. We are cutting-edge science; we are the center of "Polymer Valley."

This book is a pictorial history of the journey Akron made from around 1960 to the present. There are so many topics I could have covered when thinking about Akron over the last 55 years. After giving it some thought, I knew I had to discuss the changing downtown and its ups and downs. Someone walking down South Main Street in 1960 would not recognize it today. I had to consider what we did outside of downtown, the places where we spent time, and a little bit about the neighborhoods. Any good Akronite knows there is a difference between being from Kenmore, North Hill, or Highland Square. In addition to the distinct neighborhoods, Akron is home to some beautiful parklands, both in the county park system and the national park that runs along the Cuyahoga River,

Akron has had some colorful people lead the city, and as such it was a must that some of the larger-than-life figures of city hall be included. We also have a pretty impressive art and culture scene going on here as well. So I had to work that in as well.

The University of Akron had to have a spot; it is too important to our town to be ignored. The Zips, along with other sports teams that played in town, kept competitive juices flowing. And, of course, the music scene reached international renown in the late 1970s and early 1980s. The Akron sound became so distinctive that clubs in London were having Akron nights. Today, it is still producing artists such as The Black Keys, If These Trees Could Talk, and Joseph Arthur.

Modern Akron started in the early 1960s with the destruction of downtown that Akronites of the 1940s and 1950s had become accustomed to. According to the 1960 census, 290,351 lived in Akron, the pinnacle of the city's population. Between 1959 and 1961, the Quaker Oats Building disappeared from the landscape, and numerous mainstay businesses made way for the Cascade Superblock. People stopped shopping downtown as much when Summit and Chapel Hill Mall opened in the 1960s. A third mall, Rolling Acres, opened in 1975, and downtown as a shopping district was more or less over. The story of stores moving into the suburbs was not unique to Akron in the late 1960s. Unfortunately, neither was civil unrest. The Wooster Avenue Riots erupted in 1968, and Akron did not seem such a quiet Midwestern town anymore.

By 1970, the city's population had reduced to 275,425, and Akron was starting to shrink. In fact, it was only the second US census that had recorded a reduction in population, and it was the largest. The reduction between 1970 and 1980 would almost triple in magnitude. Downtown mainstays such as Polsky's and O'Neil's disappeared along with that reduction in population.

The 1970s saw a cultural awakening though, even as industry was starting to leave. In 1973, E.J. Thomas Hall opened, and the Akron music scene exploded shortly thereafter. In the 1970s, Akron bands such as the Rubber City Rebels, Devo, Tin Huey, and The Bizarros headlined the Crypt, which was the premiere punk club in the Midwest. The Bank followed shortly after, and the Akron sound moved. Akron compilation albums were released, and for a short time the city was a big deal in the musical universe.

In the 1980s, the population contracted by another 13.9 percent, but the National Civic League awarded Akron its All-American City designation for the first time since the organization had starting recognizing cities as such in 1949.

In the 1980s, Akronites showed pride in the exploits of Firestone High School graduate and astronaut Judith Resnik, who lost her life in 1986 during the space shuttle *Challenger* tragedy. The city also celebrated Buchtel High School graduate Rita Dove winning the Pulitzer Prize for Poetry and her many poems about Akron and Hoban High graduate Harry "Butch" Reynolds putting in a bid to be named the fastest man in the world.

In the 1990s, things should have been looking dark, as the population fell to 223,019, the lowest level since the mid-1920s. But, that same year, the $17-Million Goodyear Polymer Science Center opened, and Akron started its climb in becoming the center of the Polymer Valley. The first polymer company in Akron opened its doors in the 19th century, but it was not until the 1980s and 1990s that Akron became the polymer-manufacturing center of the country. By 2000, there were more than 400 companies manufacturing polymer-based materials in Akron and its surrounding areas. Many of the scientists at the University of Akron also did groundbreaking research at the Goodyear Polymer Center. In fact, the first College of Polymer Science and Polymer Engineering was started at the university, and the National Polymer Innovation Center opened on its campus in 2010.

In 1995, Akron was designated an All-American City for the second time. It was becoming a great place in which to live and spend time. The John S. Knight Center opened in 1993, and the National Inventors Hall of Fame followed in 1995. Canal Park brought minor-league baseball back to Akron for the first time in over 50 years in 1997, and it was a Cleveland Indians affiliate to boot. Residents could brag that they had and got to see Indians stars before Cleveland.

With the arrival of Lock 3 in 2003, downtown seemed to be revived in a way it had not been in 30 years. Restaurants and clubs started opening downtown again, and the First Night Party got rolling.

In 2006, the biomedical corridor started with the aim of bringing health-related ventures to Akron. Both the Summa Health Systems and the Akron General Health Systems have appeared on "America's Best Hospitals" lists. And Akron Children's Hospital has made major breakthroughs in treating burn victims, including being the first lab to successfully grow human skin to aid in that treatment. Summa and Akron General have longed replaced the rubber companies as the two biggest employees in Akron.

In 2008, Akron became a three-time recipient of the All-American City designation. The city had clearly weathered the storms and loss of manufacturing in the 1970s to become a city of invention and a great place to live.

This is a story about the changes that Akron underwent and the places Akronites enjoyed while that transformation was under way.

One

THE ALWAYS-CHANGING DOWNTOWN

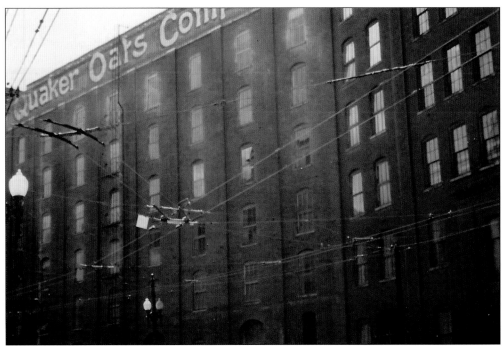

During the 1960s, as the city entered the modern age, Akron's downtown was in the midst of significant change. By the end of the decade, a good deal of the businesses everyone had patronized on Main Street had vanished, replaced by Cascade Plaza. Quaker Oat Mills, which had been a large part of Akron for decades, would leave for Chicago. But, on a day before all of those changes, photographer John Phillips decided to document what was to become a very different city. (Photograph by John Phillips.)

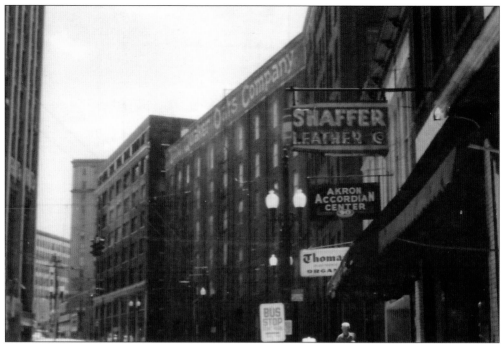

Quaker Oats, seen here from Howard and Mill Streets, was born from the German American Cereal Company, which was founded in Akron during the 1850s. The first known advertisement for cereal appeared in the *Akron Beacon Journal* in 1877. The Quaker Oats Building, torn down shortly after this photograph, and silos were a major part of downtown for decades. (Photograph by John Phillips.)

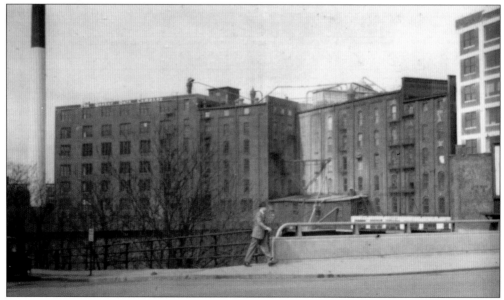

Quaker Oats, seen here from the Bowery Bridge, left a big hole in Akron for just a short time. By the early 1970s, some of its facilities had been turned into Quaker Square, a trendy shopping destination in town for years. Shortly after, the grain silos became a hotel and are now used to house University of Akron students. (Photograph by John Phillips.)

It was not all that long ago that downtown Akron was a bit more industrial and not the business, medical, and entertainment complex it is now. It is hard to imagine this scene today; the area behind the Quaker Oats Mills is within walking distance of where Canal Park and Lock 3 stand now. (Photograph by John Phillips.)

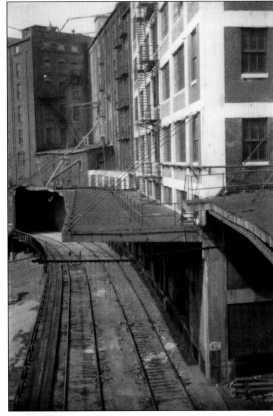

The Flatiron Building was another downtown Akron landmark in the 1960s. It survived until 1967, when the seven-story low-rise was also demolished to make way for the Cascade Superblock. A uniquely shaped building, it graced many Akron postcards. (Photograph by John Phillips.)

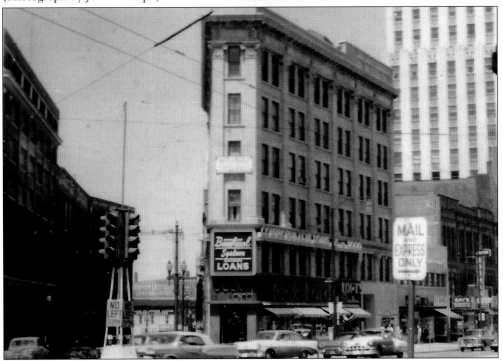

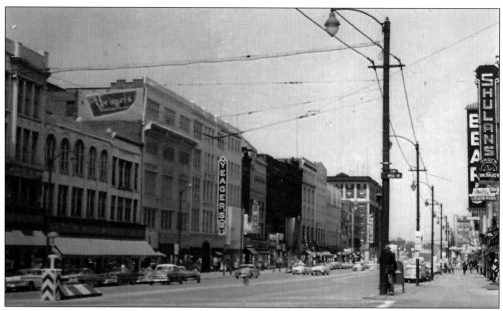

This photograph of Main Street between Mill and Market Streets may bring several longtime Akron businesses to mind that no longer exist. Shulan's, which opened on Main Street in 1921, still exists in Akron at the Fairlawn Town Center, and it is still owned by the Shulan family. (Photograph by John Phillips.)

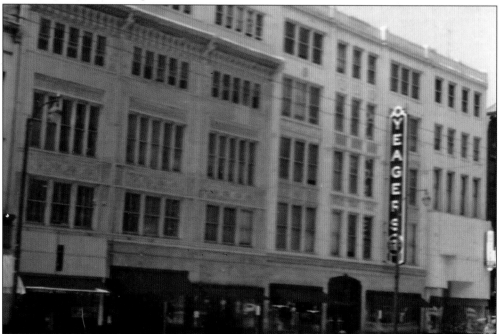

Yeager's Department Store was also an Akron mainstay for decades. Billed as "Akron's Quality Story" from 1906 to 1961, it stayed on the same block when Polsky's and O'Neil's moved farther south on Main Street around 1930. The building was another Akron landmark demolished in 1967 to make way for the Cascade Superblock. The onetime retail center of Akron was gone. (Photograph by John Phillips.)

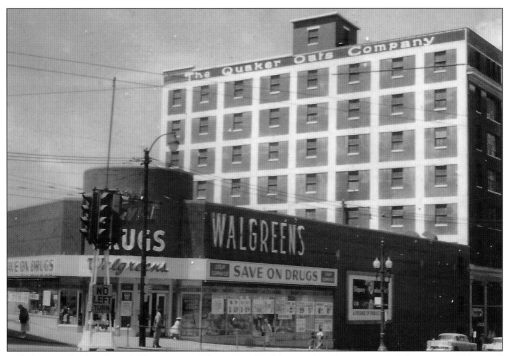

While not the landmark like some of the other buildings, the downtown Walgreens on Howard and Bowery Streets is also remembered by a lot of Akronites. (Photograph by John Phillips.)

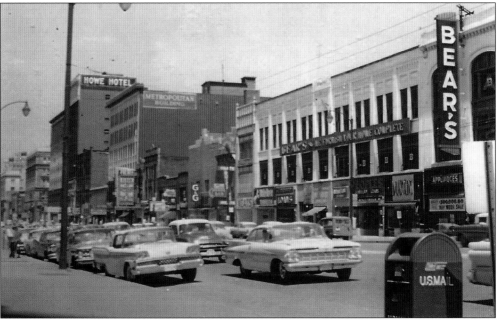

Looking north up Main Street from Mill Street in the early 1960s is Bear's, which "Furnished Your Home Complete" and was where the downtown branch of the Akron-Summit County Library now stands. Just a little farther down the road was Akron's first skyscraper. The 11-story Howe Hotel was the tallest building in Akron at one point and a luxury alternative to the Portage Hotel located on the same street (Photograph by John Phillips.)

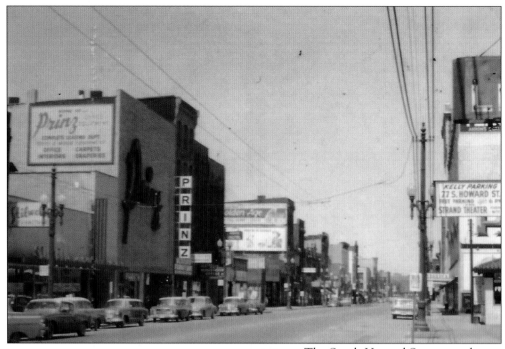

The South Howard Street seen here was not the flourishing business district as in the past, but it was still a vital part of downtown. (Photograph by John Phillips.)

Ash Street is a little bit off the beaten path when one thinks about downtown Akron, but it is right off of South Main Street. Much like the rest of downtown, it is almost unrecognizable after 50 years. (Photograph by John Phillips.)

This scene of downtown in the 1980s shows a city that is a bit more recognizable. While many Akronites may look at this photograph and wonder where certain buildings are today, they would not be as lost as they would be looking at the 1960s images. (Photograph by John Phillips.)

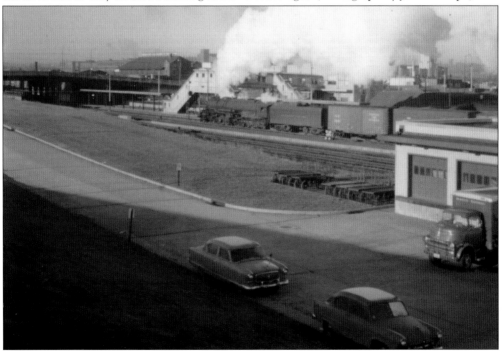

Pictured here is a Baltimore and Ohio (B&O) train passing the Erie Station. The Akron Union Station at that time was adjacent to Erie, just to the right of the photograph. Erie and Union have been used as the names for various stations throughout Akron's history. (Photograph by John Phillips.)

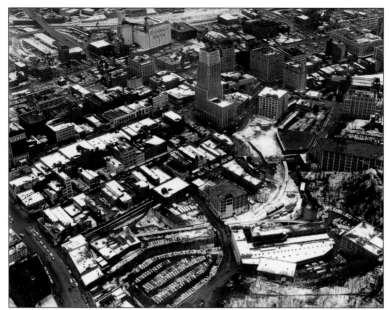

Downtown has evolved so much over the years that the early 1960s might seem unrecognizable to Akronites of today. In this photograph, current landmarks such as Cascade Plaza, Canal Park, and Lock 3 are nowhere to be found, and Quaker Square seems to be called Quaker Oats. (Courtesy of Bruce Ford.)

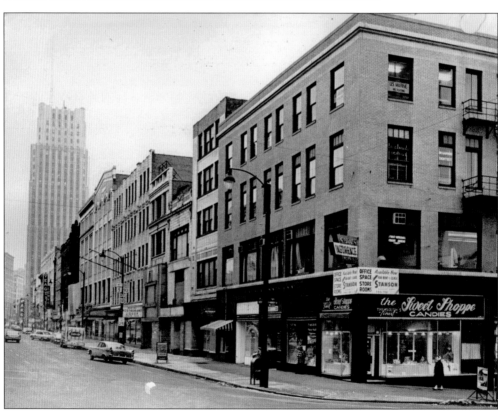

In the 1960s, a good deal of Main Street was torn down for the Cascade Superblock, the urban-renewal project. The four buildings that eventually linked the site were the Akron City Center Hotel, Cascade 1, Cascade 3, and First Merit Tower. But in the early 1960s, the block featured the Sweet Shop and Yeager's. (Courtesy of Bruce Ford.)

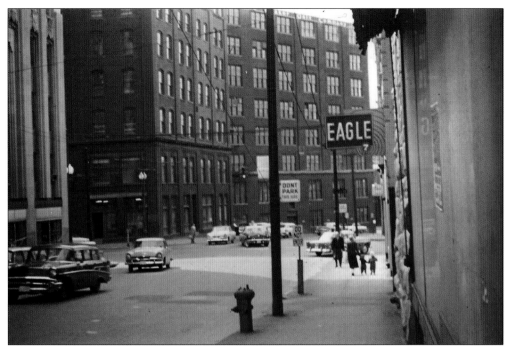

The corner of Mill and Howard was a different place back in 1960. As like in so many photographs of downtown at the time, a building that was part of the Quaker Oats Company looms in the background. (Photograph by John Phillips.)

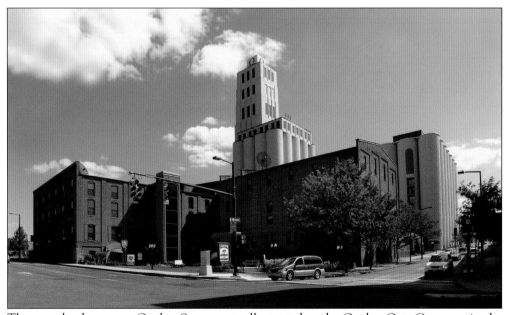

The complex known as Quaker Square actually started as the Quaker Oats Company in the 1870s, and it stayed as its headquarters until the company left for Chicago in 1970. In 1975, the building, along with its 120-foot-tall silos, began the transformation into Quaker Square. The silos became a Hilton hotel in 1980s. Later a Crowne Plaza hotel, the silos feature 196 completely round rooms. (Photograph by Bruce Ford.)

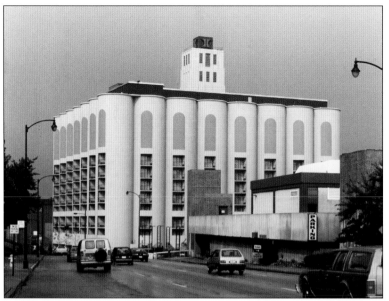

In the late 1970s, the Quaker Square Complex became a premier shopping and dining destination for the area. Opening with just four shops and an ice cream parlor in 1975, the Quaker Square General Store, Ice Cream Parlor, and its photography studio were memorable stops for Akronites for many years. (Photograph by Ott Gangl.)

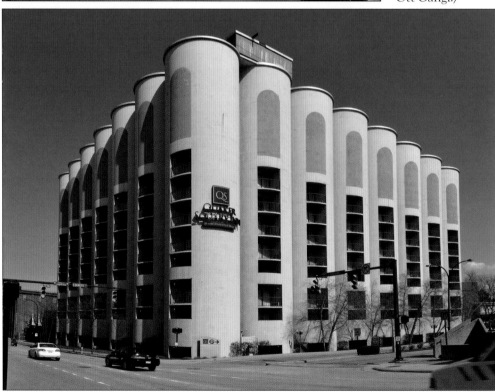

The entire complex was listed in the National Register of Historic Places in 1972, and Quaker Square's development plan made sure to incorporate Akron's history. The Trackside Grill and Ice Cream Parlor, named for the railroads that run parallel to it, celebrates Akron's history. The Trackside's dining room was completed with beams and columns from the factory building. It was bought by the University of Akron, and the hotel is used exclusively for student housing, although some stores still operate within. (Photograph by Bruce Ford.)

O'Neil's was an important part of Akron's life from 1877 until it merged with May Company in 1989 and subsequently absorbed into Macy's in 2006. Its downtown location, remembered fondly for elaborate display windows during the Christmas season, closed in 1989. Well into the 1980s, going downtown to see the display windows at O'Neil's and its rival Polsky's was a holiday tradition. (Photograph by Bruce Ford.)

This unique building was constructed in 1930 for over $2 million. Polsky's Department Store, which opened in 1885, moved to its new South Main address right by rival O'Neil's after completion of the building and stayed there until closing in 1978. The University of Akron bought the empty building in 1987 and has since used it for classrooms and administrative needs. (Photograph by Jimi Imij.)

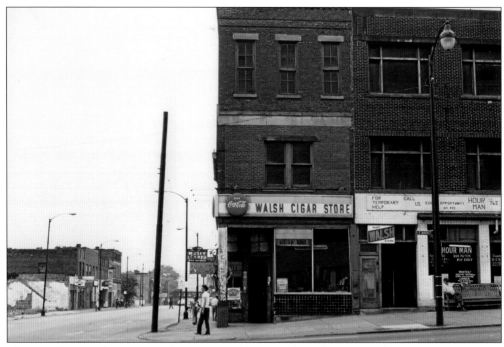

The North Howard Street area has a unique place in Akron history. In the 19th century, it was the area's main thoroughfare until the closing of the Pennsylvania and Ohio Canal moved business to Main Street. By the 1940s, the area had become a multicultural business district. While mostly African American, it also had stores owned by Polish, Italian, and Greek immigrants. When the Walsh Cigar Store, pictured here in 1976, was torn down in 1982, it was the last of the district to stand. In recent years, the district is clearly on the rebound. (Courtesy of Bruce Ford.)

Akronites from different eras have various memories of this building. While not many remember it as home of the *Akron Beacon Journal* from 1927 to 1938, many people will remember it as the home of the downtown branch of the Akron Public Library from 1942 to 1969. These days, it houses the Summit Artspace and the Akron Area Arts Alliance (AAAA). In 2010, AAAA received a grant from the Knight Foundation and renovated the second floor of the building, allowing for 3,000 square feet of performance space. (Courtesy of the *Akron Beacon Journal*.)

Getting to downtown from the north has changed as well. Built in 1922, the North Hill Viaduct was the first direct connection across the Little Cuyahoga River, which is a 17.4-mile-long tributary of the Cuyahoga River. It allowed for easy travel between the North Hill neighborhood and downtown. Immortalized in Rita Dove's "Under the Viaduct, 1932" from her Pulitzer Prize–winning book of poems *Thomas and Beulah*, it was closed in 1978 after chunks of concrete began to fall from the bridge. (Photograph by Bruce Ford.)

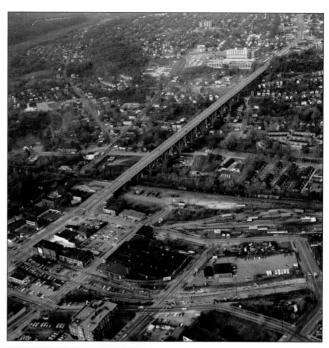

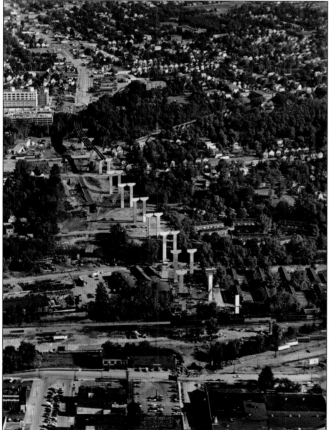

To replace it, the All-American Bridge, pictured here during construction, was built from 1980 to 1982. Also called the Y-Bridge, as its splits into two one-way bridges on the downtown side, it is 134 feet tall at its highest point. Local legend has it that at least one suicide a year occurred during the viaduct's history, and unfortunately the Y-Bridge has had 29 attempts between 1997 and 2009. In 2010–2011, $1.5 million of the federal stimulus funds were used to fence the bridge. (Photograph by Ted Walls.)

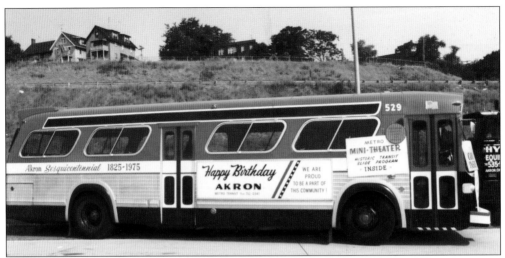

A Metro RTA bus is pictured here at the 1976 Metro Exhibit in Akron. This bus was on display in July during the city's US bicentennial celebration. The design had been unveiled a year earlier in celebration of Akron's 150th birthday. Public transportation has a long and unique history in Akron, starting in 1882 with three 12-passenger, horse-drawn carts. In the early part of the 20th century, several companies, including Goodyear, competed for Akron's mass-transit business until the Akron Transportation Company won out in 1930. (Courtesy of the Akron Metro Regional Transit Authority.)

In April 1969, facing a strike, the Akron Transportation Company closed its doors, leaving Akron as the largest city in the United States without public transportation. The Akron Metropolitan Regional Transit Authority was quickly created and negotiated new contracts with bus operators and mechanics by late summer. Now called METRO, it introduced the Summit Citizens Area Transit bus in 1975. The SCAT van is a prearranged origin-to-destination, public-transit service for older adults and persons with disabilities. The fleet of SCAT buses transports more than 390,000 passengers a year. (Courtesy of the Akron Metro Regional Transit Authority.)

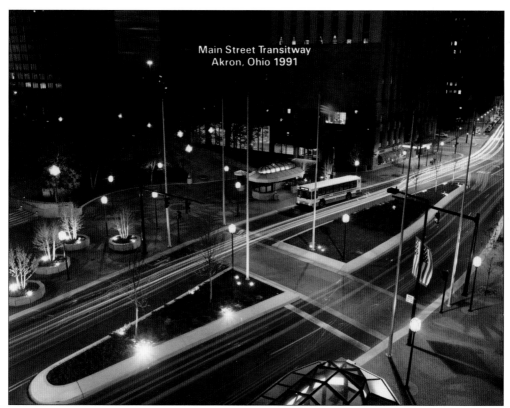

Main Street Transitway
Akron, Ohio 1991

In May 1991, the look of downtown Akron was completely changed, as the Main Street Transitway was completed. The changes came in many facets, including extensive landscaping, wider bricked sidewalks, new crosswalks, improved bus shelters, special waiting areas for riders, and wider curbs for easier accessibility to passengers boarding buses. The citizens of Akron and Summit County passed a .25 percent sales tax supporting Metro in November 1990 while waiting for the Transitway to open. This allowed Metro to expand its routes throughout the county, making it much easier for people to travel to Akron from its suburbs. In 2015, METRO operated 228 buses within Summit County. (Courtesy of the Akron Metro Regional Transit Authority.)

The 1990s saw some major additions to downtown, including Canal Park, which takes its name from its proximity to the Ohio and Erie Canal that runs behind the left-field wall of the stadium. It has a capacity of 9,447 and was designed by Populous, the same architectural firm that had designed the Cleveland Indians stadium three years earlier. Opening in 1997, a downtown ballpark was a game-changer. (Photograph by David Monseur.)

Polymer played a large part in Akron's rebirth after much of the rubber industry left. The area, known as the Polymer Valley, includes 400 polymer-related companies, of which close to 100 are within city limits. Their effect on the city and downtown is extremely evident. In 1995, the city and private investors renovated B.F. Goodrich Building 41 as the world office for Advances Elastomer Systems. (Photograph by Bruce Ford.)

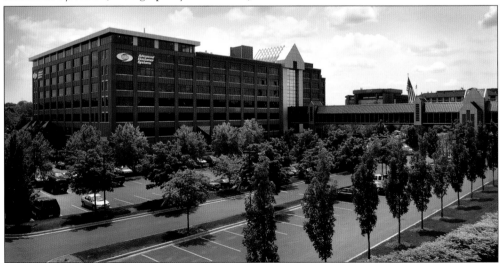

The city invested $7.4 million, along with private investments exceeding $25 million. When it was finished, the building encompassed 540,000 square feet. Adjacent to the building are a new residential apartment complex designed for young professionals and Canal Park baseball stadium, which opened around the same time. Currently, the building houses offices for the Summa Health Group, Akron Children's Hospital, and numerous other local businesses. (Photograph by Bruce Ford.)

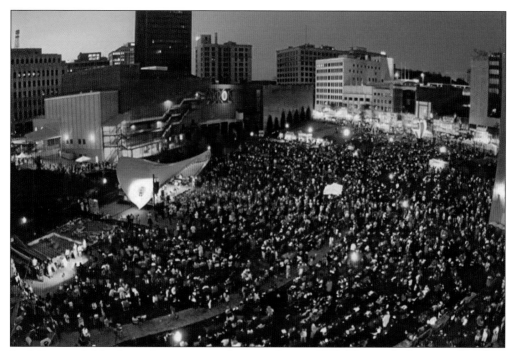

Lock 3 opened right down the street just a few years later in 2003. The amphitheater and outdoor concert venue seats 5,000 people in the summer and turns itself in to the premier ice-skating rink in the area in the winter. Lock 4, in the same facility, offers a full slate of jazz, blues, and gospel. (Courtesy of Bruce Ford.)

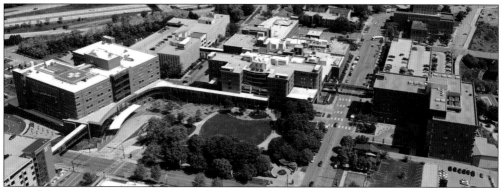

One of the biggest players in the revitalization of Akron's downtown in recent years is Akron's Children's Hospital. This shot was taken from its transport helicopter *Air Bear*. It looks out of Perkins Park, the main hospital building, and the walkway to the Kay Jewelers Pavilion. The new pavilion includes emergency facilities, neonatal intensive care, and outpatient surgery. It is a state-of-the-art facility Akron is lucky to have. (Photograph by Ted Stevens.)

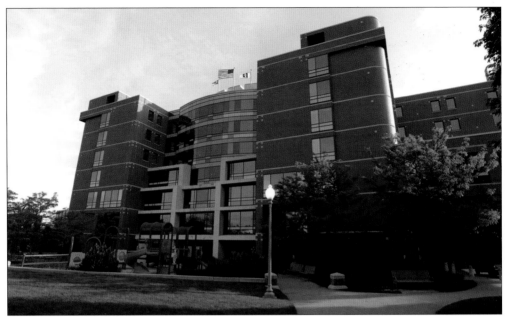

One of the newest additions to downtown, opened in May 2015, is Akron Children's Hospital's Kay Jewelers Pavilion, a seven-floor, $200-million addition to the hospital campus. Kay Jewelers is a subsidiary of Sterling Jewelers, which is headquartered in Akron, Ohio. (Photograph by Ted Stevens.)

The Akron Biomedical Corridor is designed to encourage health-related ventures into the region. Summa Health Systems, Akron General Health Systems, and Akron Children's Hospital are a large part of it, as are companies such as Akron Polymer Systems. Akron hospitals have been innovators for decades; in 1974, Akron Children's Hospital became the first hospital in the world to successfully grow human skin in a lab to treat burn victims. (Photograph by Ted Stevens.)

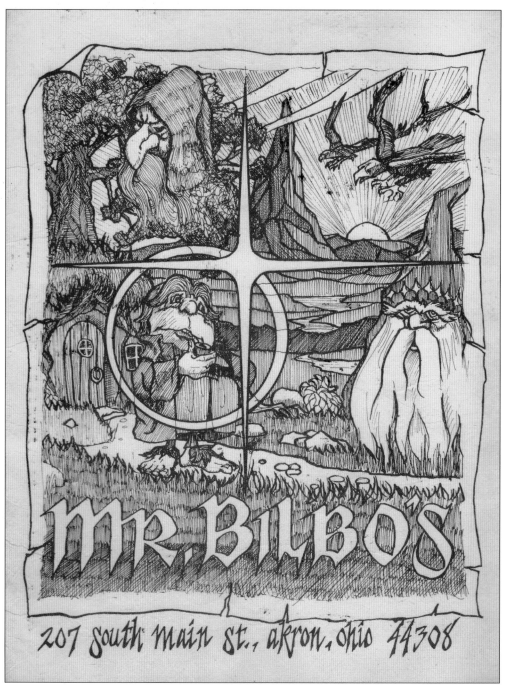

Mr. Bilbo's is fondly remembered as the cool funky bar downtown for a couple of decades, ending in 2000. The place paid homage to the smiling, pipe-smoking J.R.R. Tolkien character long before Peter Jackson did. Anyone who spent any time in Mr. Bilbo's has memories of the three-foot-tall mechanical Bilbo Baggins that sat at the end of the bar and the murals that decorated the venue. (Courtesy of Charlie Thomas.)

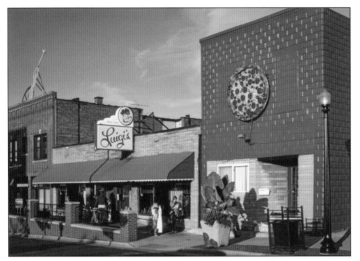

Luigi's has consistently been named Akron's best pizza for as far back as anyone can remember—it seems they were winning that award even before they opened in 1949. Luigi's legacy has been honored in local cartoonist Ton Batiuk's long-running strip *Funky Winkerbean*. The band box often shown in the strip is real and sits proudly in Luigi's. (Photograph by the author.)

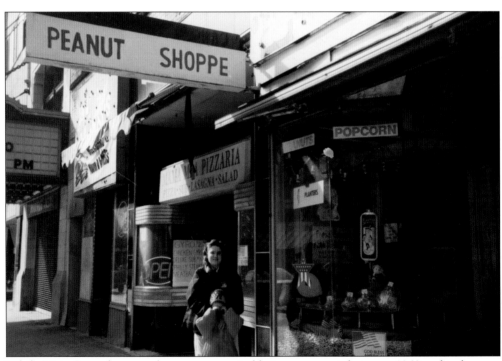

While Main Street became almost unrecognizable in many spots between 1960 and today, one always knew where to get peanuts. Opening on the corner of Howard and Main Streets during the 1920s, moving next to the what is now the Akron Civic Theatre in 1933 and then across the street, the Peanut Shoppe has weathered the changing times. Owned by Marge Kline's family since 1980, it is one of the few things Akronites can count on in the ever-evolving downtown. (Courtesy of Marge Kline.)

Two

Around Town
and the Parks

At one time or another over the last 30 or so years, almost every resident of Akron has gone to Larry's; there are a lot of places in Akron that eventually almost everyone visits. Ken Stewart's, which celebrated its 25th anniversary in 2015, looms right behind Larry's. Once known as the place to go if hungry at 3:00 a.m., Larry's has more regular hours now and continues the tradition of good food at an affordable price. Ken Stewart's opened up as a fine-dining establishment during a time when Akron really did not have any other options, and the eatery has stayed at the top of that list. (Photograph by the author.)

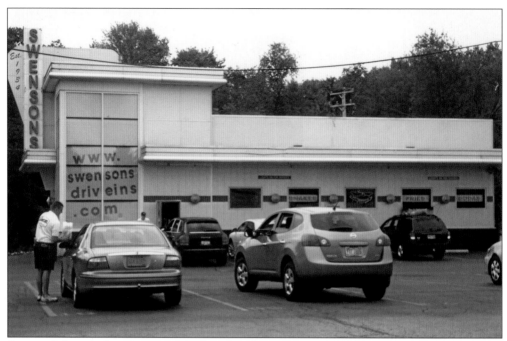

Swenson's has produced some of the best burgers in Akron since 1934. In 1935, Pop Swenson opened the first Swenson's on South Hawkins Avenue, where this store is currently located. In 1952, a second location opened on East Cuyahoga Falls Avenue, followed by Stow in 1987 and Montrose Avenue. Since then, the restaurant has moved outside of Summit County, but it is still an Akron burger. Named the third-best restaurant in Akron by *Trip Advisor* and winner of national best burger competitions, Swenson's is an Akron tradition. (Photograph by the author.)

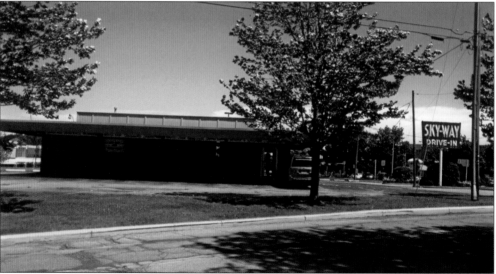

Skyway Drive-In has been a mainstay of Akron since 1952, when the Market Street location opened. Much like its rival Swenson's, the drive-in has been featured on Food Network shows and is famed for its burger. Although it lost to Swenson's on Michael Symon's *Food Feuds*, Skyway did win the category for traditional burger. After years at one location, Skyway has expanded to three Akron locations. (Photograph by the author.)

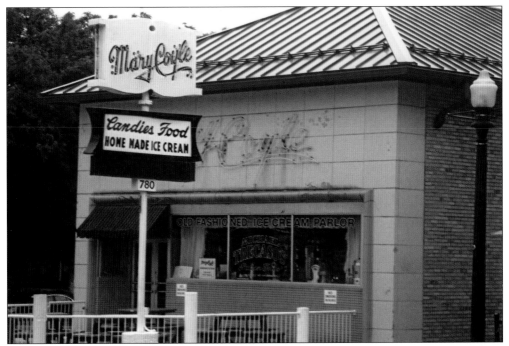

Mary Coyle's Ice Cream has been a tradition in Akron since 1937. With the motto, "Where there is no substitute for quality," it has served old-fashioned ice cream here for decades. What is new, relatively speaking, is the Trecaso family's ownership. They have been serving up some of Akron's best pizza since 1973, winning several awards in the process. (Photograph by the author.)

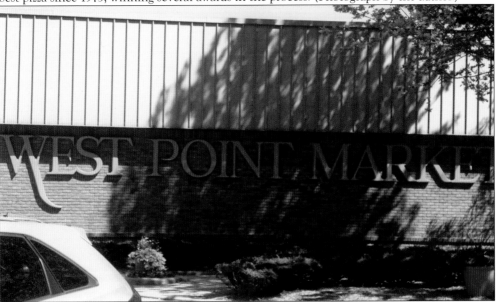

The Westpoint Market has earned its slogan "a market like no other" for supplying Akron with a premiere specialty market for 75 years. The current building has undergone six expansions and 29 remodels during its 69 years; it never stopped growing. Unfortunately, the current building will be closing at the end of 2015, as the land it is located on was sold. The story of the West Point Market may not be over yet. (Photograph by the author.)

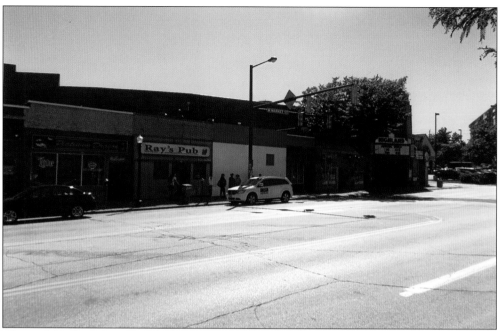

The Highland Square Neighborhood is considered one of the most eclectic areas in Akron. It is densely populated, having both multistory apartments from the 1920s and 1930s as well as modern high-rises. It is a highly progressive area and has had the headquarters of Democratic presidential candidates situated in it. The LGBT community is very prevalent in the area, and the commercial part of the district is anchored by the Highland Theater. On the other end of the street in its commercial district is Annabell's Bar and Lounge, a live music mecca in town for decades. Every summer, the neighborhood hosts Art in the Square featuring local artists, performers, and musicians and drawing over 10,000 to the neighborhood (Photographs by the author.)

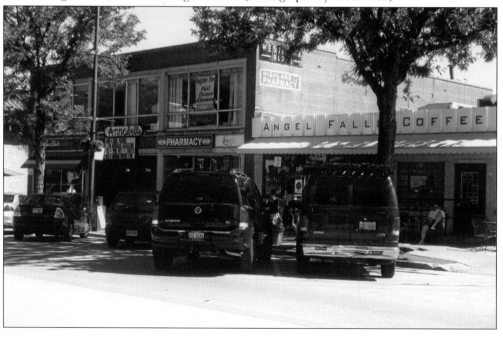

Decades of holiday cheer were created by Archie the snowman at Chapel Hill. Even though everyone had to go see Santa, no Christmas season would be complete without hearing what Archie had to say via mall employees and a microphone. Started in the late 1960s until 2003, Archie was a fixture at the mall. In 2012 and 2013, he was revived, looking a bit different, to adorn Lock 3. In 2014, he came back to Chapel Hill. (Courtesy of Sam Simon.)

Thacker's Hamburgers lasted from the 1920s until the 1980s on East Market Street. In 1975, longtime employee Jim Lowe opened the Hamburger Station. With a horse named Red as a mascot, it served onion-heavy burgers with no ketchup. Lowe had 16 Hamburger Stations dotting Akron at one time (Photograph by the author.)

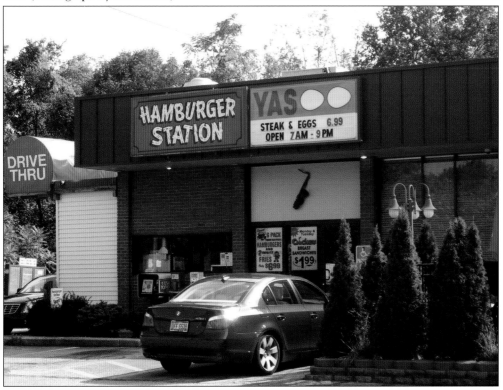

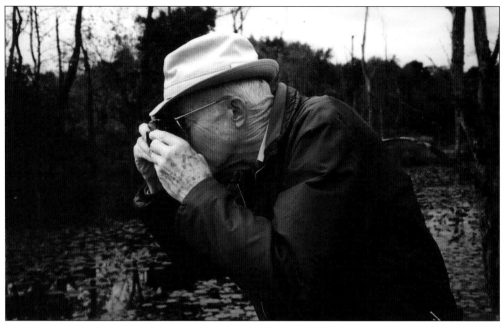

John F. Seiberling was the grandson of Goodyear Tire and Rubber Company founder Frank Seiberling. Although he served his family's company as an attorney from 1950 to 1970, famously refusing to cross picket lines during strikes, it is his years as representative for Ohio's 14th District from 1971 to 1987 that he is most remembered. (Courtesy of the John F. Seiberling collection.)

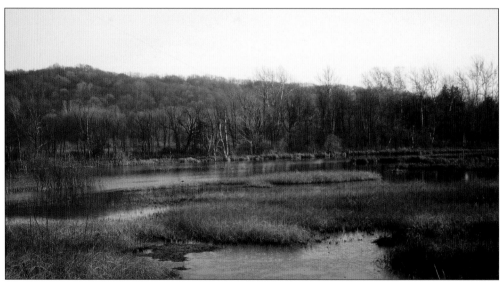

As a congressman, Seiberling participated as a delegate to the Middle East in 1975 and served on the House Judiciary Committee during the impeachment hearings of Pres. Richard Nixon. His legacy was that of a conservationist. After his retirement, he was an avid photographer of the park system he helped create. This photograph, taken by Seiberling, is the duck pond in wetlands on Riverview Road. (Photograph by John F. Seiberling.)

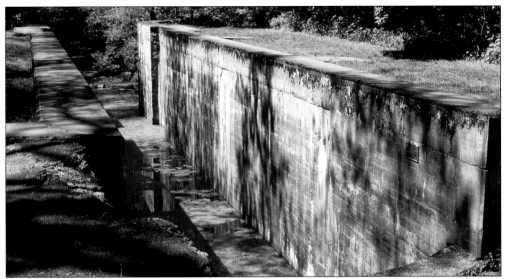

Seiberling was regarded as the patron saint of many of today's national park systems, chairing both the Alaska Lands Subcommittee and the House Interior Subcommittee on Public Lands. He was largely responsible for the 1980 Alaska Lands Act, which doubled the size of America's national parks. More importantly for Akron, he sponsored the act that in 1974 designated 32,000 acres in northeast Ohio as the Cuyahoga Valley Recreational Area. This restored lock is part of the park. (Photograph by John F. Seiberling.)

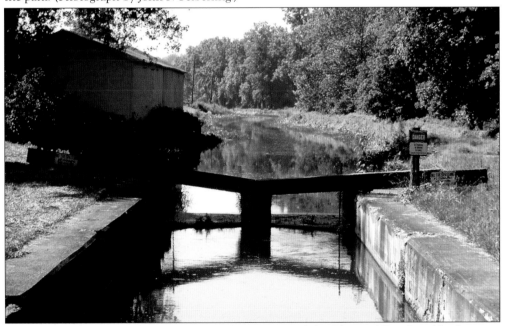

The park is largely situated around the Cuyahoga River and the Ohio and Erie Canal Lock system that allowed products and people to move back and forth between Lake Erie and northern Ohio in the 1800s. For his efforts, Seiberling was awarded the Presentational Citizens Medal by President Clinton. In 2006, a federal building and courthouse were named after Seiberling. Many of the photographs he took of the local parks, such as this one, are now housed at the Akron-Summit County Library. (Photograph by John F. Seiberling.)

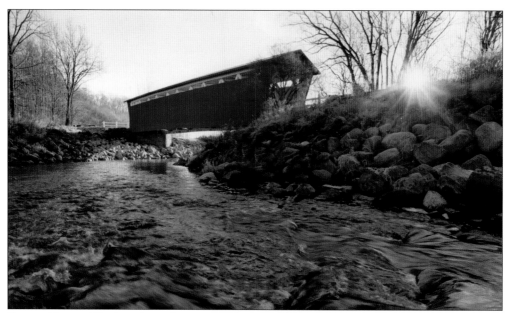

Everett Covered Bridge, the only remaining covered bridge in Summit County, is also part of the Cuyahoga Valley National Park. In 2006, the National Park Foundation put the bridge on its list of the top-10 places for photography on public lands, as this image from 1990 attests. In 1975, residents rebuilt the bridge after a spring storm, and the National Park Service completed an accurate historical reconstruction of the bridge in 1986. (Photograph by Lew Stamp.)

Alongside the park, the Summit Metro Parks also serve the Akron area. Rep. Seiberling's grandfather F.A. Seiberling, founder of Goodyear Tire and Rubber, sat on the initial board of park commissioners and was instrumental in the establishment of the park system, which includes over 20 locations and trails. (Photograph by the author.)

A centerpiece of the Summit Metro Parks, the F.A. Seiberling Nature Realm is a 104-acre educational nature center that includes this 10,000-square-foot visitors' center with exhibits, kids' areas, live animals, and a gift shop featuring educational and locally made items. F.A. Seiberling not only helped oversee the establishment of the parks but donated 400 acres in the organization's early days. (Photograph by the author.)

The F.A. Seiberling Nature Realm grounds showcase a suspension bridge over a 45-foot-deep ravine, several gardens with plant identification, observation decks, two ponds, wetlands, hiking trails, and a grass prairie. Off of Smith Road, not far from Sand Run Park, it is a rare park in which dogs are not permitted, as it is a special-use area that has been set aside for the study and enjoyment of nature, including the hand-feeding of chickadees. (Photograph by the author.)

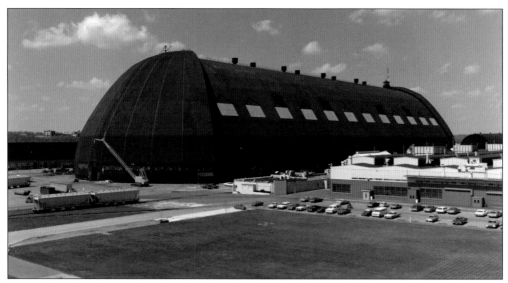

Every Akronite has driven by the Goodyear Airdock more than a few times, and even though it is technically not open to the public, many have been inside. In 1986, when this photograph was taken, the United Way of Summit County had an event on-site—first public viewing of the hangar in 50 years, which drew 200,000 people. In 1992, some 30,000 people showed up to hear Bill Clinton speak during his first presidential campaign. (Courtesy of the *Akron Beacon Journal*.)

Over the last 20 years, traffic at Akron-Canton Regional Airport has grown every year, with the exception of 2001 (in large part because of the drop-off in air traffic the fourth quarter of the year). In 2005, some 1.43 million passengers flew through Akron-Canton, which was three times the number from 2005. Even with the growth of commercial passengers, over 75 percent of the traffic is general aviation, meaning civil aviation other than scheduled air services. In the 1980s, the airport was a bit quieter. (Courtesy of the Akron-Canton Airport.)

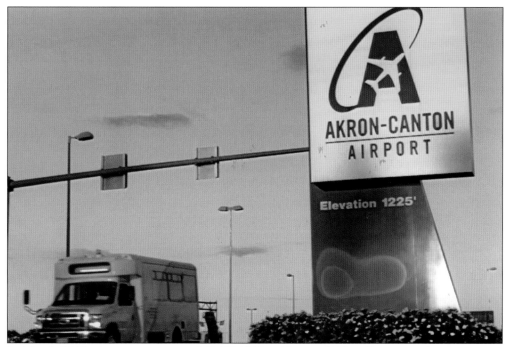

In March 2008, the airport initiated CAK 2018, a 10-year, $110-million capital-improvement plan that encompasses 10 separate projects. Already completed was an extension of one of the runways to allow for nonstop traffic to anywhere in the United States and throughout Mexico and Canada. Once everything is completed, the airport will offer international flights. (Courtesy of the Akron-Canon Airport.)

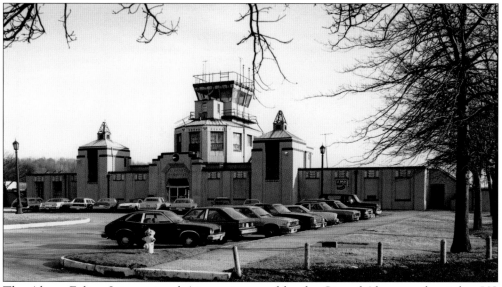

The Akron Fulton International Airport is owned by the City of Akron, and as it has US Immigration and Customs facilities, it is technically an international airport, although it has only served general aviation for many years. The terminal seen here is in the National Register of Historic Places, and in 1985 the airport was recognized as the third National Landmark of Soaring. (Photograph by Bruce Ford.)

At its peak, the *Cathedral of Tomorrow* show was aired on over 600 stations across the world. Rex Humbard's family members essentially became television stars, as they were often featured on the show. Humbard himself was inducted into the Broadcasters Hall of Fame in 1993 and was named one of the Top 25 Architects of the American Century by *US News & World Report* in 1999. (Courtesy of Rex Humbard Jr.)

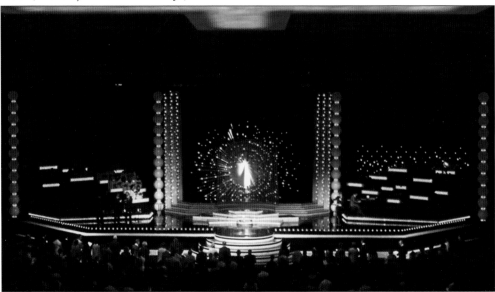

The Cathedral of Tomorrow itself was built in 1958 for a then-astronomical fee of $4 million. The church had seating for 5,400, as well as room to allow for television equipment, a crew, and the chorus. It televised to eight million people worldwide, and its stage hosted Johnny Cash and other celebrities. In 1994, the cathedral was sold to television evangelist Ernest Angley. (Courtesy of Rex Humbard Jr.)

Three

THE SPORTING LIFE

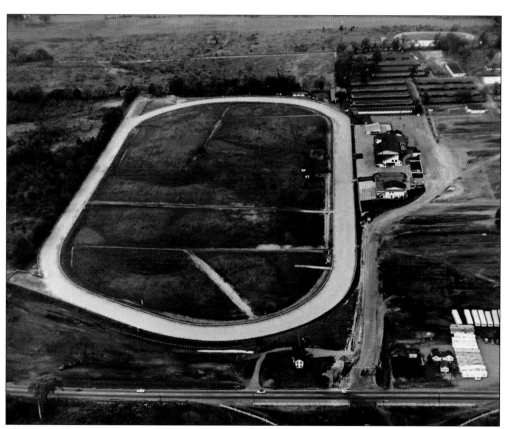

The Ascot Park Race Track, a three-quarter-mile track built in 1923, was a 63-acre space located on Ohio State Route 8. The last renovation was in the mid-1950s, and on opening day in 1955 it hosted 12,525 fans. Shortly after this photograph was taken in 1961, when it was still a racetrack, it began changing hands. It served as everything from circus grounds to a motorcycle racetrack. By the mid-1970s, the grounds had become a safety hazard and were burned down in 1976 as a training exercise for local firefighters. But, in 1961, it was still Akron's horse-racing track. (Courtesy of the *Akron Beacon Journal*.)

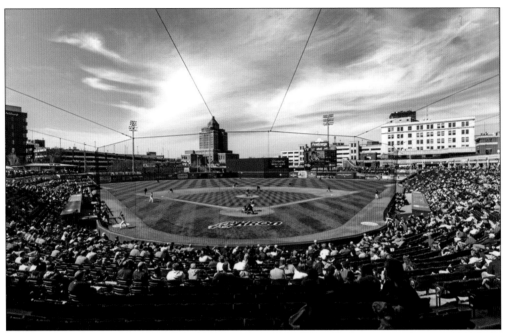

The Aeros were a hit from the beginning, with over half a million in attendance in 1998, an unheard of number for Double-A baseball. When the Canton-Akron Indians moved to Akron in 1997, it was the first time the city had minor-league baseball, or any professional sports, played within its city limits since 1941. As one can see, the fans enjoyed having a team downtown. (Photograph by David Monseur.)

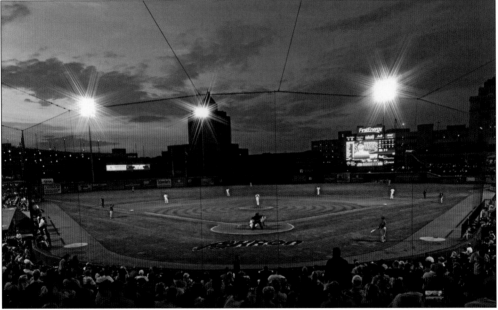

Located right down the street from Lock 3 and the Civic Theatre, the lights of Canal Park light up downtown during the summer. The Aeros have also provided Akron a winner for most of their time here, posting 14 winning seasons in 19 years. They have also funneled a fair amount of players and two managers up to the big leagues in Cleveland. (Photograph by David Monseur.)

In 1997, their first season in Akron after moving from Canton, the Akron Aeros had a contest to name the mascot. Nine-year-old Daniel J. McFarland won with the suggestion of Orbit, who remained the Aeros mascot until the team changed its name to the Rubber Ducks in October 2013. (Photograph by Ed Suba Jr.)

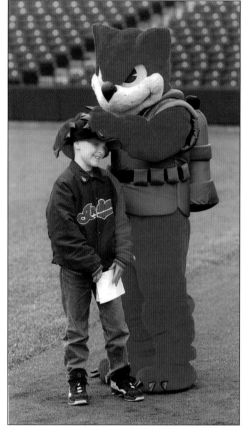

Akron fans had voted to keep the Aeros name, which came from Akron's connection to the aerospace and aviation industry. In 2009, the Aeros polled 67 percent of the vote in a run-off with three other finalists. But, in 2013, then-owner Ken Babby went ahead with a name change. Luckily, the trading off of mascots was peaceful. (Photograph by David Monseur.)

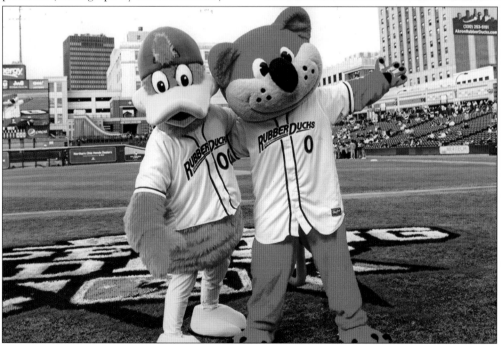

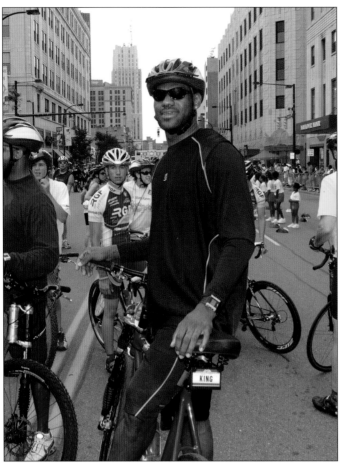

Akron's most popular athlete is certainly LeBron James. An Akron native, James first came to attention with the Amateur Athletic Union Northeast Ohio Shooting Stars. He enjoyed success on a local and national level even before he entered high school. James, who was raised Roman Catholic, went to high school at St. Vincent-St. Mary High School in Akron. He was named Ohio's Mr. Basketball and was named to *USA Today*'s All-USA First Team as a sophomore, junior, and senior. He was named the Gatorade National Player of the Year as a junior and senior and appeared on the cover of *Sports Illustrated* as a junior. (Photographs by Bruce Ford.)

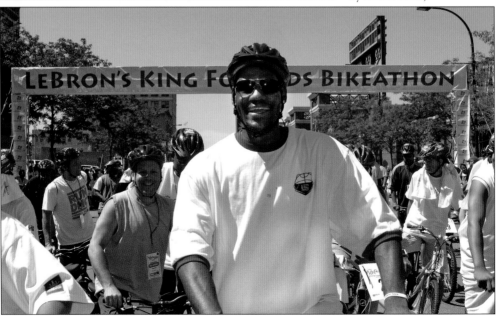

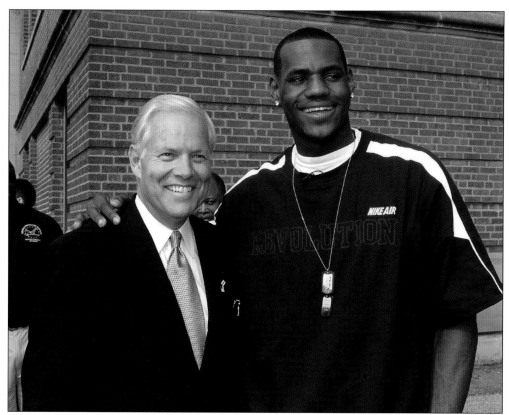

James has starred for the Cleveland Cavaliers, right up the road from Akron, from 2003 to 2010 and then returned to the Cavaliers in 2015. He has always stayed connected to the city of Akron, keeping a residence in the area. More importantly, he has stayed involved with the city's children. James, pictured above with Mayor Don Plusquellic, organized the event LeBron James' King for Kids Bikeathon from 2005 to 2010 and Wheels for Education since 2011. (Photographs by Bruce Ford.)

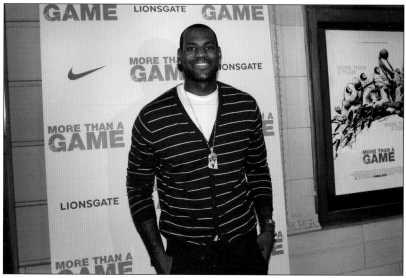

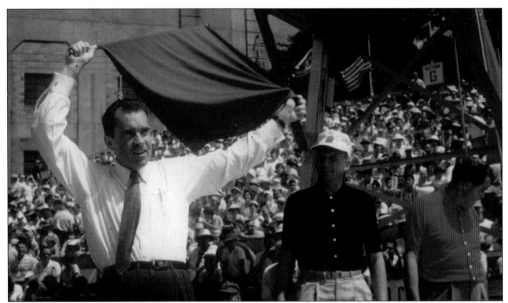

The All-American Soap Box Derby is a racing program that has been run in the United States since 1934. The first year it was in Dayton, Ohio, but it moved to Akron in its second year, as Akron had more of a central location and hilly terrain. In 1936, Akron built a permanent track for the racers at Derby Downs, but it was in the 1960s and into the early 1970s that the derby became one of Akron's biggest annual events. Its popularity is evident here with grand marshal Vice Pres. Richard Nixon waving the green flag. (Courtesy of Jeff Lula.)

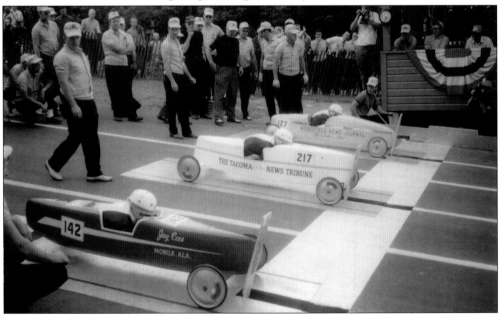

During the All-American Soapbox Derby's biggest years, Derby Downs would expect attendance up around 70,000 people. During those peak years, Chevrolet sponsored the event, which was only open to boys between 11 and 15. They were all the champions of their local events from around the country as well as a few from a number of other countries. At one time, the derby was one of the top-five sporting events in the country in terms of attendance. (Courtesy of Jeff Lula.)

During those peak years, the derby always had famous television and movie stars or even important political figures make appearances and function as grand marshal. Then–vice president Richard Nixon and *Bonanza* star Lorne Greene both served in that capacity. In 1972, Chevrolet pulled out of sponsoring the event. Since then, a number of different companies have sponsored the derby, but it has seen decreasing participation and attendance since then. (Courtesy of Jeff Lula.)

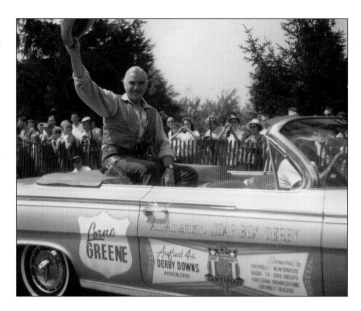

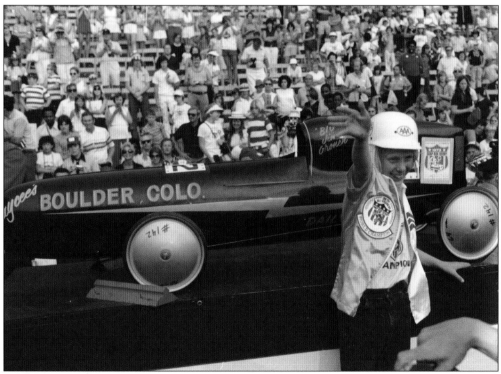

In 1973, the derby actually found itself immersed in scandal, as 14-year-old Jimmy Gronen was found to have a car with an electromagnet built into the nose, activated when Gronen leaned his helmet against the back of his seat. His wheels were also found to be chemically treated in a way that reduced the rolling resistance of the tire. Gronen's uncle and legal guardian, wealthy engineer Robert Lange, was indicted for contributing to the delinquency of a minor and paid a $2,000 fine. (Courtesy of Jeff Lula.)

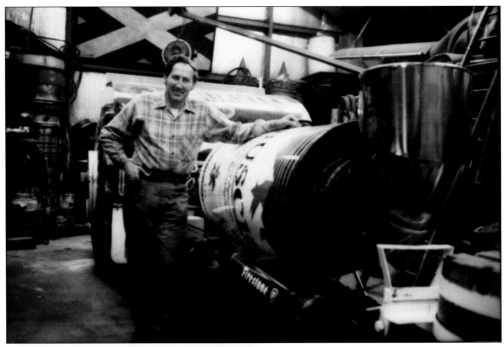

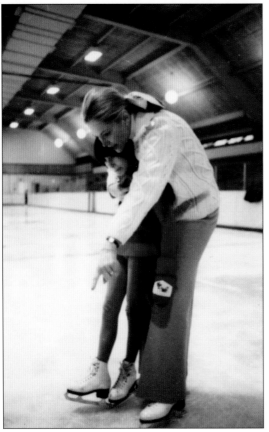

Akron native Art Arfons was the world land speed record holder three times in 1964 and 1965 with his *Green Monster* series of jet-powered cars. Arfons, who was a member of the International Motorsports Hall of Fame, Motorsports Hall of Fame, International Drag Racing Hall of Fame, National Tractor Puller Hall of Fame, and Summit County Sports Hall of Fame, is seen here standing next to one of his *Green Monster* turbine-engine tractors that he used in tractor pulls. The year before this photograph was taken, he had won the NTPA championship in the 9200 modified class. (Photograph by Ott Gangl.)

New York City–born Olympic gold medalist Carol Heiss Jenkins has long been part of the Akron and northeast Ohio figure-skating world. Heiss won five world championships, two North American championships, four US championships, and an Olympic silver medal in 1956 and a gold in 1960. She later retired to Akron and established herself as a premier figure-skating coach not only in the area, but internationally. (Photograph by Ott Gangl.)

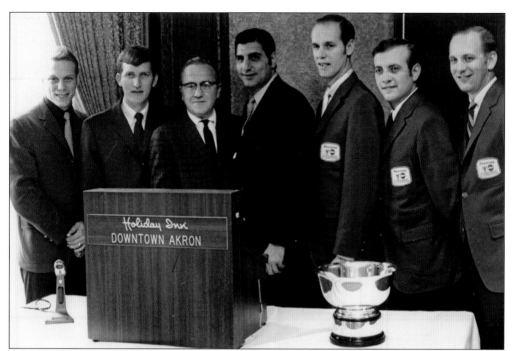

In 1958, Akron sports agent Eddie Elias was instrumental in the creation of the Professional Bowling Association (PBA). The PBA originally had its headquarters in Akron, and its signature event was the Tournament of Champions at Riviera Lanes on South Miller Road. Pictured here from left to right in 1969 are the five television finalists: Jim Goodman, Don Johnson, an unidentified Firestone executive, Elias, Dave Soutarm, Jim Stefanich, and Wayne Zahn. (Courtesy of the Pro Bowlers Association.)

Harry "Butch" Reynolds is probably the fastest man ever born in Akron. His specialty was the 400-meter dash and the 4x400-meter relay. He won the gold medal for the relay and the silver for the 400-meter at the 1988 Seoul Olympics. He also was a three-time world champion, two-time silver-medal winner, and onetime bronze medalist. He held the world record for the 400-meter for 11 years with his personal best time of 43.29 seconds that he ran in 1988. (Photograph by Bruce Ford.)

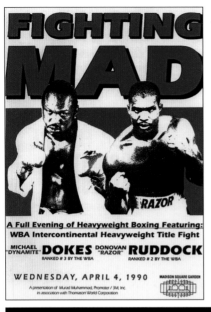

Michael "Dynamite" Dokes was the pride of Akron in the 1980s and early 1990s. He owned at least one of the three heavyweight boxing titles from 1982 to 1990, winning the North American Boxing Federation (NABF) title in January 1982 until he lost the World Boxing Association (WBA) title in April 1990. Sports fan will always remember Dokes bringing a WBA heavyweight championship to the Akron area in 1983 when he fought Gerrie Coetzee at the Richfield Coliseum. (Courtesy of Sam Simon.)

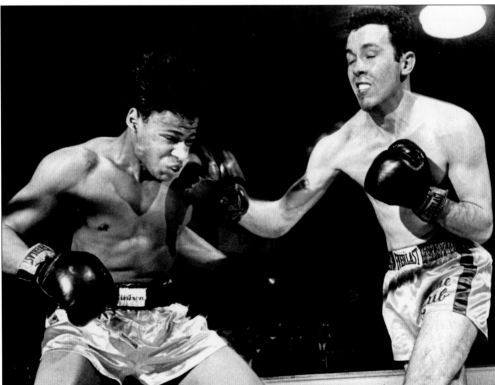

Boxing was an extremely popular sport in Akron, especially when the city reigned as the rubber capital of the world. With the rise of other sports such as basketball and football, boxing's popularity slowly began to dwindle. The last boxing match in the Akron Armory, pictured here, was held on April 5, 1980. The Akron Armory was then used as a training site for the Akron Police Department before being torn down to clear the way for the construction of the Oliver Ocasek Government Office. (Photograph by Ott Gangl.)

Firestone Country Club has played a significant role in the history of professional golf. The Rubber City Open was held there from 1954 to 1959. The PGA championship was played there in 1960, 1966, and 1975. Since 1962, the World Series of Golf, now known as the WCG-Bridgestone Invitational, has been held at Firestone. Jack Nicklaus, pictured here in 1962, did well at the course for many years, winning the original four-man tournament four times and finishing as runner-up another six times. He also won the inaugural event of the second edition of the tournament. (Photograph by Ott Gangl.)

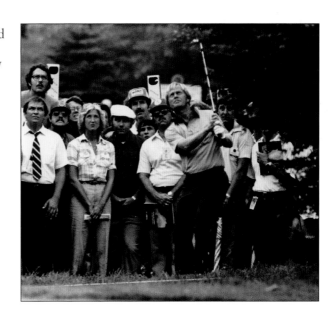

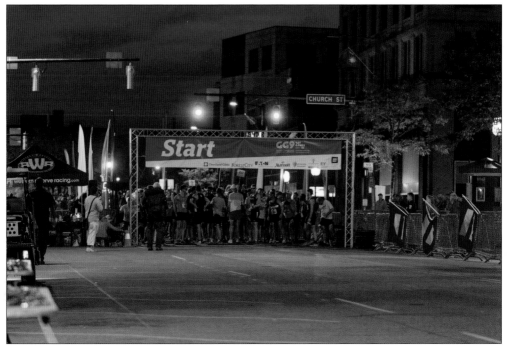

In 2014, Gay Games 9 was presented by the Cleveland Foundation and held in sporting venues in both Cleveland and Akron. A study released in December 2014 said the games, held between August 9 and 16, drew thousands of people to the region and had a $52.1-million economic impact on the area. Both the marathon and half-marathon were held downtown, and the Akron Civic Theatre recognized and welcomed the athletes to the city. Bricco and the Angel Falls Coffee shops also participated as hospitality partners for the Akron events. (Photograph by Jeff Shaw.)

Several Akron businesses stepped up to be sponsors for the 2014 Gay Games: Akron General Hospital, Summa Health Systems, Sterling Jewelers, Canapi, County of Summit, Ken Stewart's, the Innerbelt, the Gay Community Endowment Fund of Akron Community Foundation, and of course the University of Akron. The Akron-Summit County Convention and Visitors Bureau made sure both athletes and fans stayed busy. (Photograph by Jeff Shaw.)

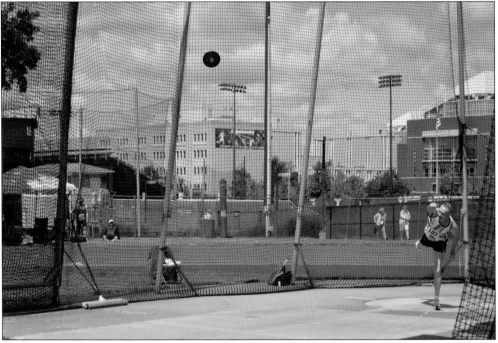

The track and field events were held between August 11 and 15 and included the long jump, high jump, triple jump, pole vault, shot put, hammer throw, discus throw, javelin throw, men's decathlon, and another 14 events. The events were all held at Lee Jackson Track and Field Complex, which offers an eight-lane, 400-meter Rekortan surface and specific venues for the other events. (Photograph by Kelly Murphy-Stevens.)

Four

CITY HALL AND IN THE NEWS

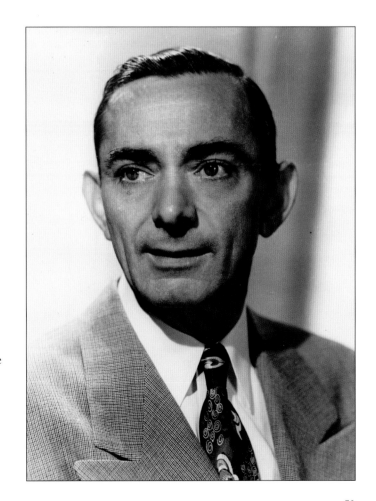

Leo A. Berg was the 54th mayor of Akron (1954 to 1961) and helped usher in the modern age for the city. He was a delegate to the Democratic National Convention in both 1956 and 1960 and served as the chairman of the League of Mayors. His national responsibilities brought him to Washington, DC, on a regular basis, and he became friends with John F. and Jackie Kennedy. (Courtesy of Bruce Ford.)

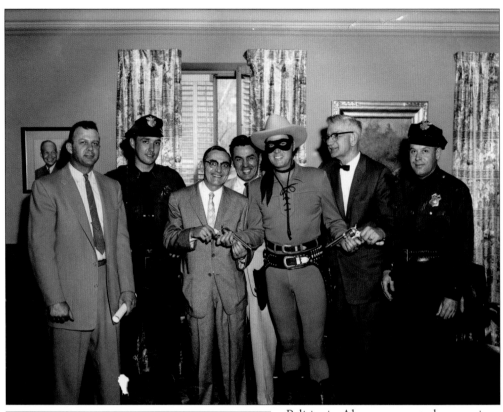

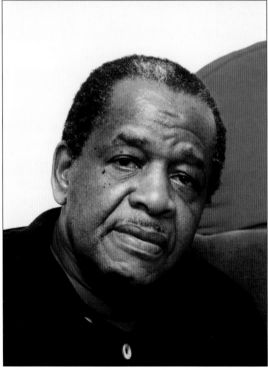

Politics in Akron were not always serious business. For instance, consider the day Leo A. Berg and a group of Akron officials welcomed the Lone Ranger to Akron. While it was supposedly a children's show, the mayor, policemen, and other members of city hall seem very anxious to get into the photograph with him. (Courtesy of Bruce Ford.)

Ed Davis was the first African American elected official in Akron's history, winning the election to become clerk of courts in 1957. He stayed in office until 1988 and during his over 30 years in office developed a reputation as a fiery and outspoken community leader devoted the principles of equality, opportunity, and fairness. The Ed Davis Community Center in the Perkins Park neighborhood is named after him and serves the inner-city Akron community. (Photograph by Ott Gangl.)

Ed O. Erickson was the 55th mayor of Akron (1962 to 1965), and while his time in office was short, it was certainly eventful—for reasons both positive and tragic. Akron boomed commercially during his time in office, as Summit Mall opened during his tenure and Chapel Hill Mall shortly after. Unfortunately, his time in office also saw the Tallmadge Parkway collapse, now known as Memorial Parkway, in which three people were killed. (Courtesy of Bruce Ford.)

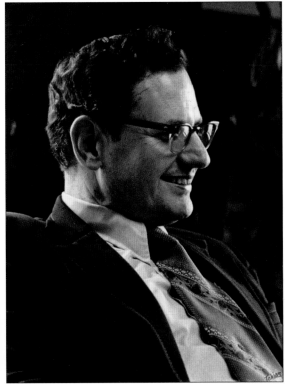

John S. Ballard, the 56th mayor of Akron, held the office during a turbulent period of Akron history. Ballard, who served as the city prosecutor from 1956 to 1964, was mayor during the United Rubber Workers strikes of 1967 and 1976, which saw the closing of plants all across Akron. The Wooster Avenue riots also occurred during Ballard's tenure, and he has been frequently credited with lessening their severity. Quaker Square opened, and most of the work of Cascade Plaza was performed under his watch. Mayor Ballard is remembered as a steady hand during a troubling time. (Courtesy of Bruce Ford.)

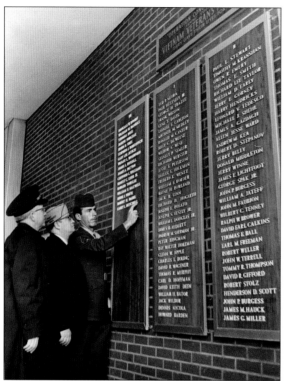

Pictured in 1968, from left to right, Maj. Morris Richardson, James Seminaroti (adjunct, Summit County Council of War Veterans), and Sgt. Mike Rowe read the names of Summit County Vietnam War veterans on the wall of the City-County Safety Building on Center Street in Akron, Ohio. (Photograph by the *Akron Beacon Journal*.)

In July 1968, a series of riots broke out over a period of days in the Wooster Avenue area of Akron. What started the rioting is still argued to this day, as is the nature of the riots themselves. On July 16, the police were called to several fights in the area between gangs from the north and west sides of the city. (Courtesy of the *Akron Beacon Journal*.)

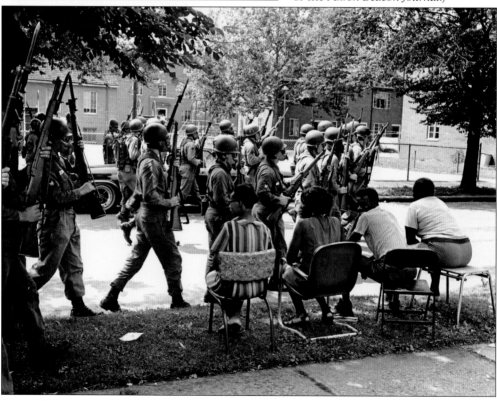

The warring gangs continued their disputes as police poured into the area, and curfews were established. On the morning of July 17, residents in the area began to gather on Wooster Avenue, protesting rumors of violence by the police. Tension between the neighborhood and the police were high due to perceptions of discrimination and police brutality; the arrests of some of the residents proved a flash point, and soon a full-scale riot was under way. (Courtesy of the *Akron Beacon Journal*.)

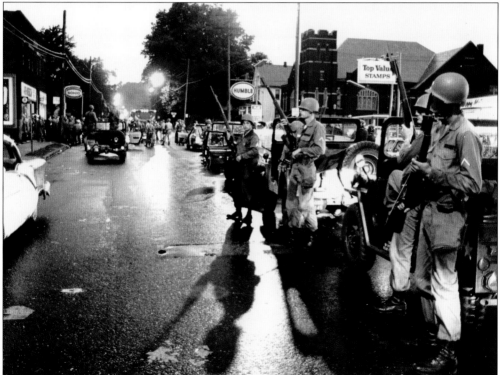

The riot soon poured into downtown, and the National Guard deployed a large amount of tear gas in the area, which ended the rioting, as those living outside the area left. During the confrontation, the National Guard was encamped inside the Rubber Bowl. The riot officially ended on July 23, 1968, and Mayor John Ballard appointed an independent commission to investigate the root cause of the incident by July 26. (Courtesy of the *Akron Beacon Journal*.)

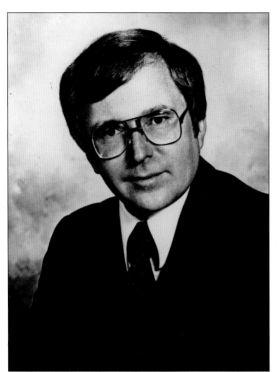

Roy L. Ray was the mayor of Akron from 1979 to 1983, but he is probably best remembered as the representative for the 27th District of the Ohio Senate from 1983 to 2001. During that period, he pushed, and succeeded in, having the numbers of rays of light reduced from 17 to 13 in the seal of the State of Ohio. Ray was involved in controversy near the end of his career when it became public that he earned more than $160,000 from Ohio Edison as a consultant while voting on issues affecting them. Ohio law had required he disclose the consulting income but not the client. (Photograph by Bruce Ford.)

Thomas C. Sawyer first entered politics when he was elected to the Ohio House of Representatives in 1977. In 1984, he became the 58th mayor of Akron, and while he only served one term, most Akronites will remember he and Tom Watkins, another Akron-area politician who succeeded in the Ohio House, bet their mustaches on the Mondale/ Reagan presidential election in 1984. Sawyer, a Democrat, has been clean-shaven ever since. Sawyer served in the US House of Representative for Akron from 1987 to 2003 and is currently a member of the Ohio Senate. (Photograph by Bruce Ford.)

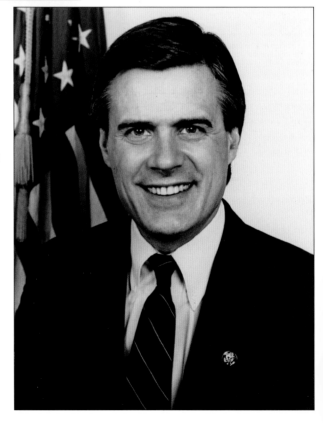

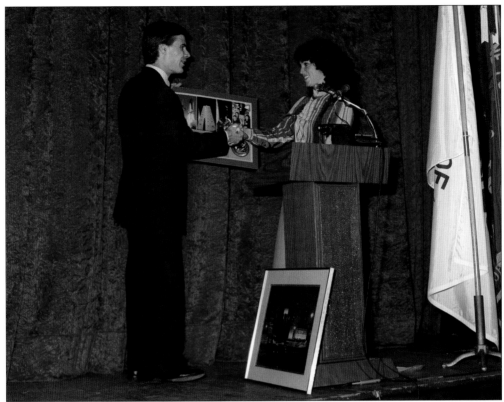

Astronaut Judith Resnik graduated from Firestone High School in 1966, signifying greater things down the road with a perfect SAT score. Resnik's first foray into space was as a mission specialist on *Discovery* in the fall of 1984. Her second mission was aboard the ill-fated *Challenger* mission, which disintegrated 73 seconds into its flight, resulting in the death off all seven on board. An Ohio Historical Marker on Firestone High School grounds and an elementary school named in her honor are among the ways Akron honors her contributions. Honors occurred during her life as well; Resnik is pictured here at a ceremony with Mayor Tom Sawyer. (Photographs by Bruce Ford.)

Donald L. Plusquellic was not just the 59th mayor of Akron. His 28 years in office made him the longest-serving mayor in Akron's history. In fact, his tenure is roughly as long as the next three mayors combined. Plusquellic is pictured here with his three predecessors, who served a combined 20 years between them, with Ballard having the second-longest tenure in the city's history at 13 years. Plusquellic arguably shaped Akron as nobody before had ever done. (Photograph by Bruce Ford.)

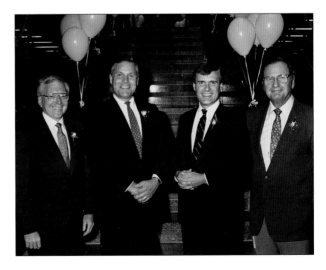

Plusquellic served on the Akron City Council for 13 years before being elected mayor. Like any politician, he has had his detractors, but his tenure has been highly successful. The Brookings Institute called Akron an economic-recovery model for other cities to follow. He has won numerous national awards that attest to Akron being among the best places in the nation to live. (Photograph by Bruce Ford.)

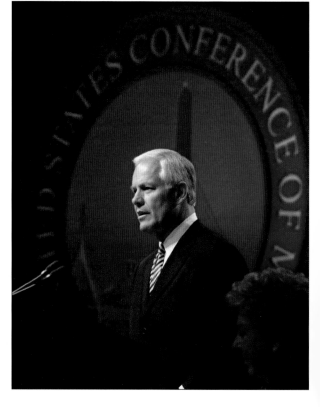

Plusquellic has participated in politics on both the national and international levels as well. President Obama selected him to be part of a team of mayors from across the country to work at solving the global financial crisis of 2008–2009 on the local level. Plusquellic also served as the president of the US Conference of Mayors in 2004 and 2005. (Photograph by Bruce Ford.)

Garry L. Moneypenny was sworn in as Akron's 60th mayor in May 2015. Moneypenny has served the city of Akron for over 30 years and as the president of city council became mayor after the abrupt resignation of longtime mayor Don Plusquellic. Moneypenny spent most of his career in law enforcement, serving in local police and sheriff's departments from 1978 to 2011. He has also been the representative from Ward 10 on the Akron City Council since 2001. Only 10 days after being sworn in, he announced he would be resigning because of a too-personal encounter in his office. (Photographs by Bruce Ford.)

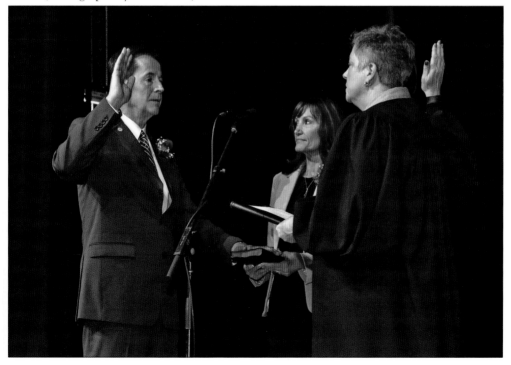

For 28 years, the City of Akron had one mayor—then in the span of 10 days it had three. The third mayor, replacing Moneypenny, is Jeff Fusco. Only recently becoming the council president, Fusco took becoming Akron's 61st mayor in stride, was sworn in a private ceremony, and called for Akronites to "just breathe." Fusco served as the chairman for the Summit County Democratic Party and has announced he will not run for reelection. (Photographs by Bruce Ford.)

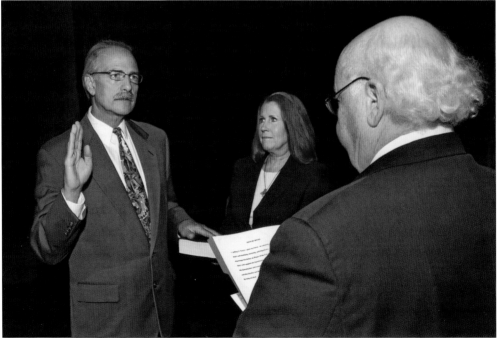

Five

ARTS AND CULTURE

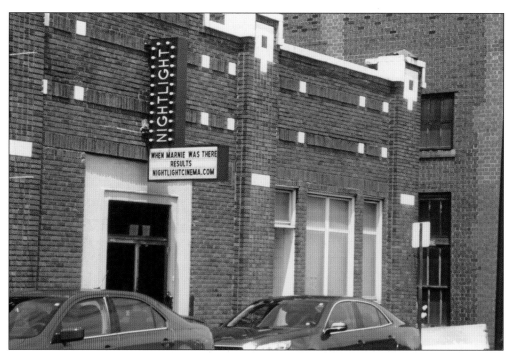

In July 2014, the Nightlight Cinema opened in downtown Akron on North High Street, and Akron finally had an independent cinema. Several local foundations help with funding, as did a $21,000 *Kickstarter* program. The team that put the Nightlight together, Akron Film+Pixel, has been producing a film festival at the University of Akron since 2002 but felt Akron need a theater specializing in foreign, classic, and American independent films. They were right. (Photograph by the author.)

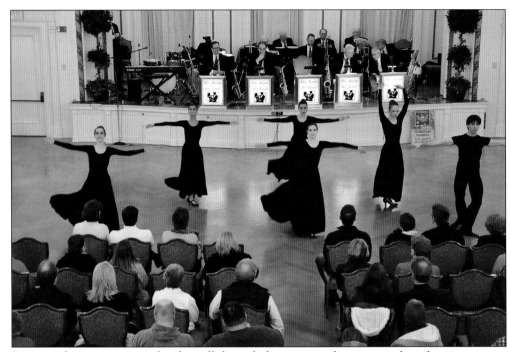

Events and entertainment take place all through downtown at locations such as the art museum, Akron Civic Theatre, downtown public library, Greystone Hall, John S. Knight Center, the Nightlight, Summit Art Space, and the Zion Lutheran Church. The city plays host to acts from big bands to ballroom dancing, such as the exhibition pictured here at Greystone Hall in 2013. (Photograph by Majestic Imaging Ltd.)

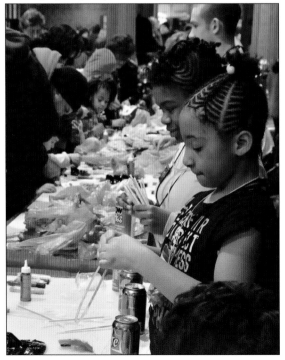

First Night is downtown Akron's own New Year's Eve celebration. The event, which started in 1995, is a little different than most New Year's Eve celebrations, as it is very family-friendly and alcohol-free. While there are a lot of the usual events that signal New Year's Eve festivities, there is also a selection of kids' craft events, pictured here. (Photograph by Majestic Imaging Ltd.)

First Night is a collection of various types of artists. Theater, music, dance, and the visual arts are all on display. The festivities are supported by organizations such as the *Akron Beacon Journal*, Akron Community Foundation, METRO, PNC Foundation, the City of Akron, Akron Fresh Market, First Merit Foundation, Summit County, the Ohio Arts Council, and Goodyear. It is always a hit, and Akronites pack the streets for it. (Photograph by Majestic Imaging Ltd.)

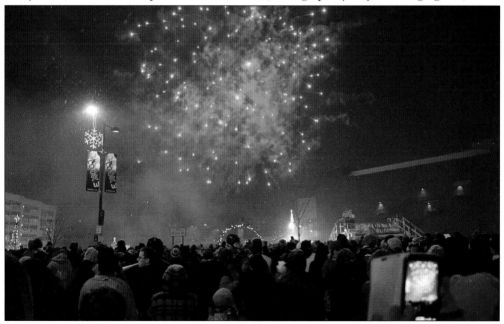

Of course nothing ends a big party downtown like fireworks. First Night has fireworks both at 9:00 p.m. for the children and midnight for everyone who stays up late enough to ring in the New Year in Akron. (Photograph by Majestic Imaging Ltd.)

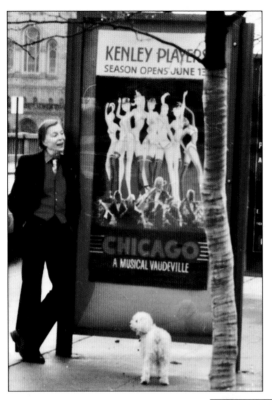

The Kenley Players billed themselves as America's most exciting summer theater, and they were probably right. They brought television and film stars to towns that usually did not see stage productions with names in them. John Kenley, seen here outside E.J. Thomas Hall in 1978, produced over 500 productions in towns across Pennsylvania and Ohio from 1940 to 1995. *Chicago*, which starred Allen Ludden and Sue Anne Langdon, was his first production in Akron. It was hardly his last, as he produced almost 90 productions between 1978 and 1987 and again in 1995. (Photograph by Ott Gangl.)

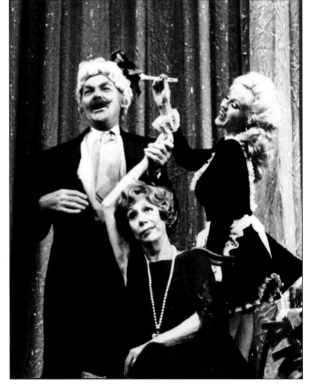

The 1981 season ended with the original Kenley Players production of *Greenwich Village Scandals of 1923*, starring Cyd Charisse (right), Imogene Coca (center), and Rip Taylor (left). The season had already seen productions starring Robert Urich, Debbie Boone, Don Ameche, and Billy Crystal, but an original production was something a bit unique. It was both written and produced by John Kenley. (Photograph by Ott Gangl.)

The Akron Art Museum has been part of the cultural landscape of the city since it opened in two rooms in the basement of the public library in 1922. The remodeled building, pictured here in 1981, was constructed around 1900 and originally served as the Akron Post Office. The red metallic sculpture in front is titled *Eagle Wheel*, a creation of Mark di Suvero. The museum's collection focuses on works created after 1850. (Photograph by Ott Gangl.)

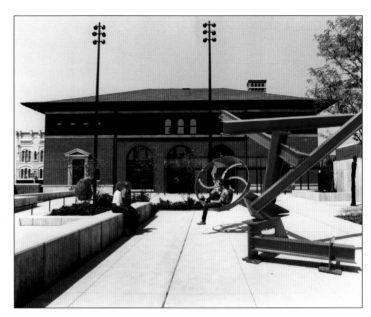

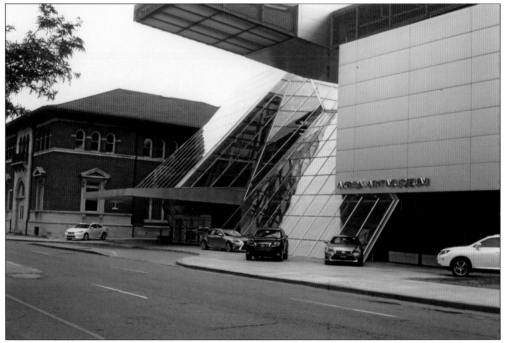

The current building was designed, or at least the large addition to the old building, by the Viennese architectural firm Coop Himmeb(l)au after an international competition. The firm had a strong reputation for adapting historic buildings within their designs, which was a goal of the city. Ground was broken in 2004 and opened to the public on July 17, 2007. (Photograph by the author.)

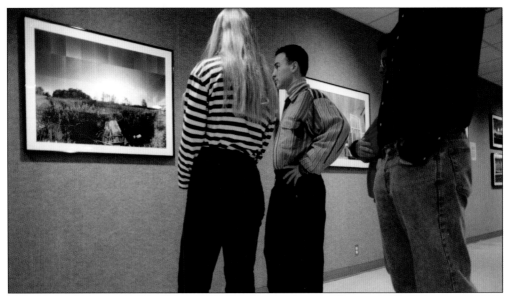

The Akron Art Museum has done many special exhibits over the years. In the spring of 1992, a number of museum patrons view an exhibit on toxic waste in Ohio—an exhibit that created some controversy in the city. (Courtesy of the *Akron Beacon Journal*.)

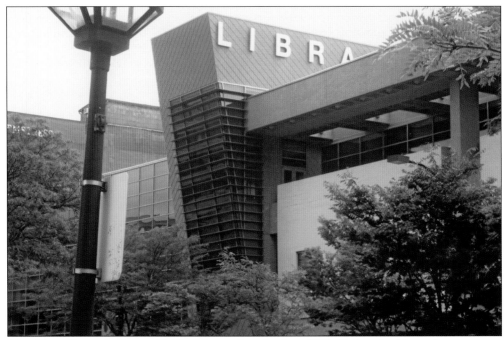

The Akron-Summit County Public Library dates back to 1874. Today, the library has over two million items in its collection and 335,000 cardholders. The downtown branch moved to 60 South High Street in 1969; however, from 2001 to 2004, it was located in a store on East Tallmadge Avenue during a renovation project. Changing technology and the need for new and more services merited the renovation and expansion, and the library reopened on October 10, 2004. (Photograph by the author.)

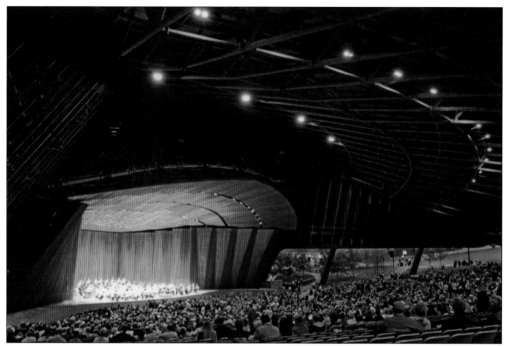

While actually in Cuyahoga Falls, the Blossom Music Center is just 10 miles from downtown Akron and an essential part of the culture of the city and all its suburbs. The facility itself has a pavilion that seats 5,700 people with room for about another 13,500 on its lawn, although the facility has gone way over that mark on a few occasions. Originally situated on over 800 acres, the facility has sold off land to the National Park Service over the years, allowing the center to protect its natural setting. (Photograph by Mark Mindlin.)

Blossom caters to many tastes: while to many it is the summer home of the Cleveland Orchestra, to some it is where Lilith Fair, Lollapalooza, and Ozzfest are held, and to others it is the premier country music venue in the area. Regardless, very early on, the lawn at Blossom became the place to be soon after its opening. This photograph from 1971 could have been captured at a John Sebastian, Supremes, or Sonny and Cher concert; all played Blossom Center. (Photograph by Ott Gangl.)

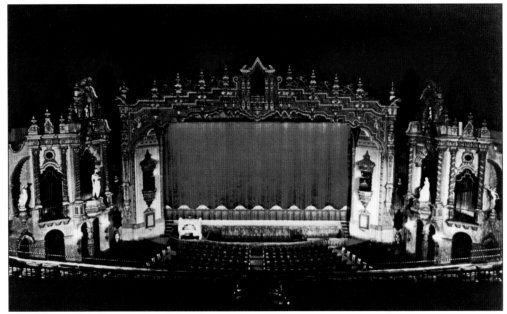

The Akron Civic Theatre's history began in 1919 when Akron dance hall owner L. Oscar Beck began construction of a theater to be called the Hippodrome. Unfortunately, the project went bankrupt by 1921, and the building stayed vacant until 1925, when Marcus Lowe chose it as a spot for one of his theaters. The Civic now stands as the last of the 11 theaters Lowe personally opened. In 1965, the owners of the theater were planning on turning it into a parking lot, so the Akron Jaycees bought it for $60,000 and renamed it the Akron Civic Theatre. (Courtesy of Akron-Summit County Public Library.)

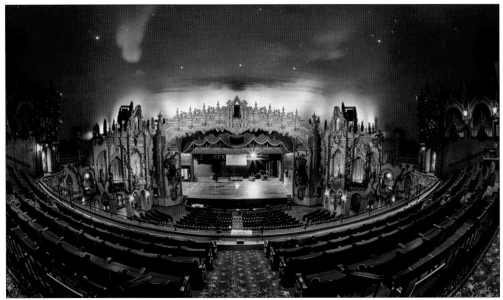

In 1966, the Women's Guild was formed, and their efforts have been the cornerstone of the theater. In 2002, the Civic Theatre closed its doors to complete a $22.5-million restoration and reopened with comedian Tim Conway. In 2004, the Civic Theatre celebrated its 75th anniversary. (Photograph by Kathleen Nelson.)

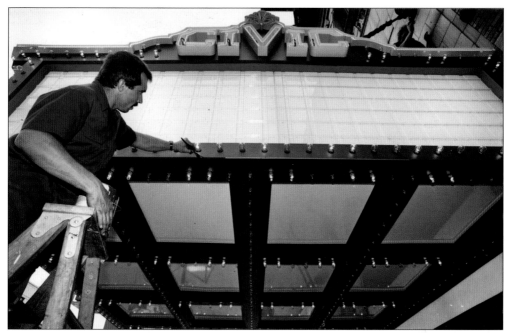

One of the biggest renovations to the Civic Theatre over the years has been a new marquee, added to the Main Street theater in 1992. Bob Balash of Ellet Neon & Plastic Sign Inc. puts the finishing touches on the marquee in this photograph. The renovation was part of a project funded by a $175,000 state grant. (Photograph by Kevin Casey.)

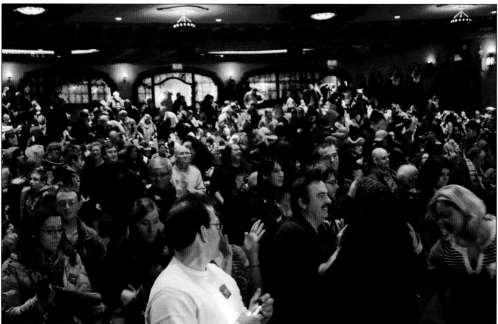

Today, the Akron Civic Theatre stands as a showplace in downtown Akron. It presents live theatre, concerts, and comedy and even hosts weddings. Right down the street from Lock 3, it is where Akron goes for entertainment. Pictured here is a packed audience to see the Pink Floyd Concert Experience at First Night 2014. (Photograph by Majestic Imaging Ltd.)

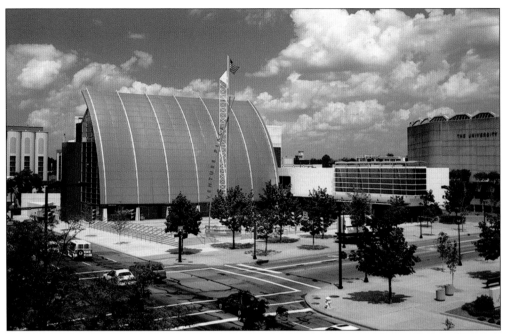

The National Inventors Hall of Fame (NIHF) was established in 1973 and located in Washington, DC; however, after a number of years, a larger location was clearly needed. For some time, it was assumed the facility would relocate to Philadelphia, Pennsylvania. But, in 1987, Akron attorney Edwin Oldham, the representative from the National Council of Patent Law Association, led the movement to place the hall of fame in Akron. The construction of the building was finished in 1995, and the hall opened in July of that year with a massive party at the facility. Unfortunately, attendance never reached its expectations, the museum never showed a profit, and it eventually moved to Alexandria, Virginia, in 2008. Many of the hall's outreach programs were successful, so the facility became the NIHF STEM (science, technology, engineering, and mathematics) Learning Center, a middle school in Akron. (Photographs by Bruce Ford.)

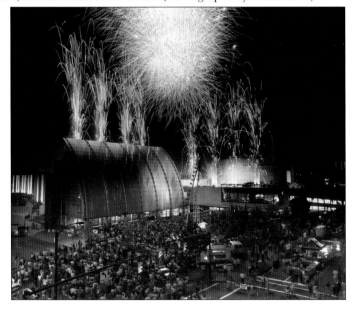

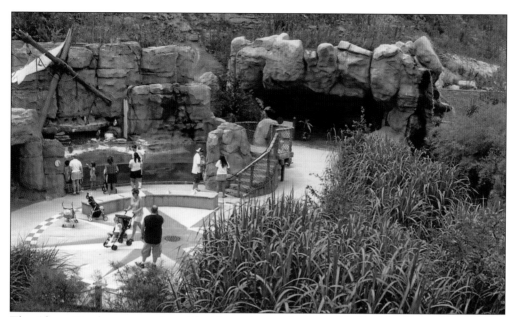

The Akron Zoo has grown alongside Akron during the second half of the 20th century, often mirroring its progress. Akron's Children's Zoo was opened in 1953 in association with the Akron National History Museum. It illustrated Mother Goose rhymes with live animal exhibits. It is still very child friendly, as all the strollers at the Legends of the Wild Exhibit would suggest, but it is not really recognizable today. (Photograph by David Barnhardt.)

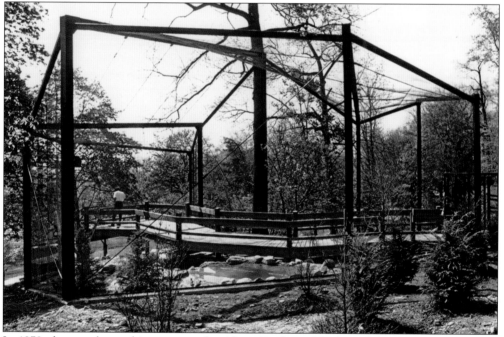

In 1979, the zoo changed its name to the Akron Zoological Park, and the city turned over the running of the zoo to a board of trustees. Akron still owned the land, but the nonprofit zoo owned everything else. Exhibits like as this aviary from 1979 took on a North and South American theme to provide a stable base for education and conservation. (Courtesy of the Akron Zoo.)

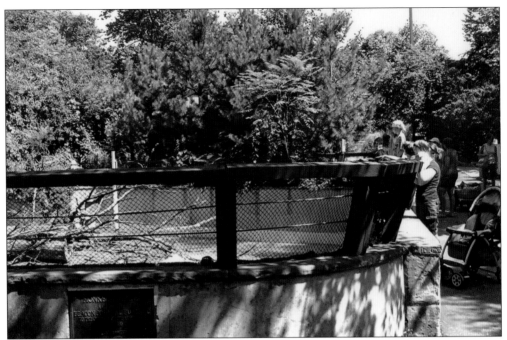

The zoo made nearly $500,000 in improvements between 1985 and 1988. Special events and improvements drove the 1988 attendance up to 133,000 patrons, breaking the old record of 128,344 from 1957. The zoo received accreditation from the American Association of Zoological Parks and Aquariums, greatly enhancing its national reputation. (Courtesy of the Akron Zoo.)

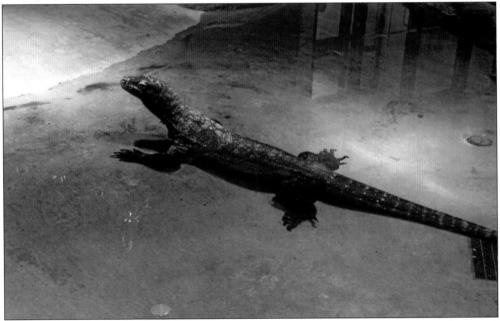

Today, the zoo is the most visited attraction in Summit County and is rated among the top 10 zoos in the United States. With exhibits such as the Komodo Kingdom (shown here), along with Penguin Point, Grizzly Ridge, and Tiger Valley, the Akron Zoo is a major part of the region's life. (Photograph by David Barnhardt.)

Six

THE AKRON SOUND

Arguably, the first significant rock 'n' roll band to come out of Akron was the Poor Girls. They were certainly the only significant female rock 'n' roll band in the area. Formed in 1965 by Susan Schmidt, Deborah Smith, Pam Johnson, and Esta Kerr, the band had a large local following. They drew the interest of local rock critic Jane Scott, who profiled them in the *Cleveland Plain Dealer*. They opened for bands such as Cream and Steppenwolf before breaking up in 1969. (Courtesy of Susan Schmidt-Horning.)

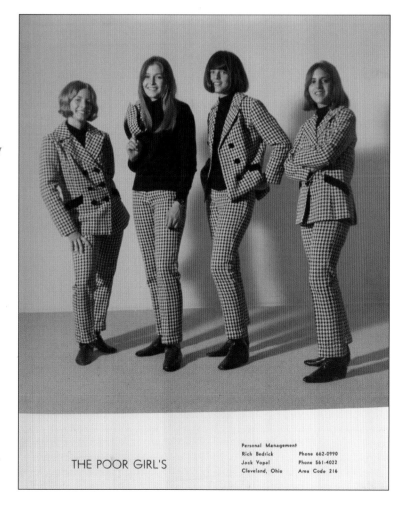

THE POOR GIRL'S

Personal Management
Rich Bedrick Phone 662-0990
Jack Vopal Phone 561-4022
Cleveland, Ohio Area Code 216

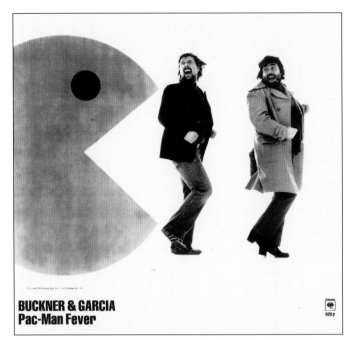

BUCKNER & GARCIA
Pac-Man Fever

Jerry Buckner and Gary Garcia were part of the Akron music scene in the late 1960s and early 1970s. While Garcia was playing in fan favorite The Outlaws at the Castle, Buckner and his band Wild Butter were recording a classic among Akron rock 'n' roll albums with their self-titled 1970 LP. Working together, they recorded "You Gotta Hear the Beat" as Animal Jack in 1972 while appearing on *The Ghoul* and writing jingles for local businesses such as Nelson's Stag Job and the Quonset Hut and the theme to the "Scream in The Dark" Haunted House. (Courtesy of Jerry Buckner.)

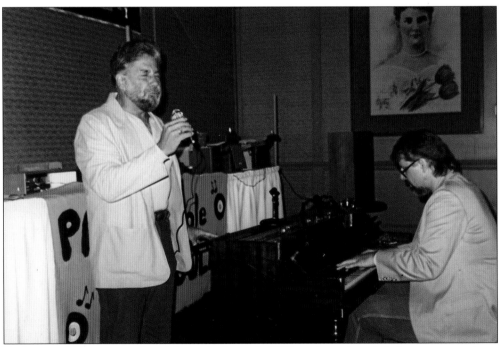

Buckner and Garcia moved to Atlanta in the early 1970s and continued their success, scoring a top-10 single with "Pac-Man Fever" in the 1980s. They also wrote the single "Footprints in the Sand" for Edgel Groves. They have stayed connected to Akron, writing 2010's "Keeping the Dream Alive" and donating all proceeds for the song to the Soap Box Derby and performing at their 20th high school reunion at Buchtel High School. Garcia passed away in 2011, but Buckner is still active, writing music for the *Wreck-It Ralph* movie franchise. (Courtesy of Jerry Buckner.)

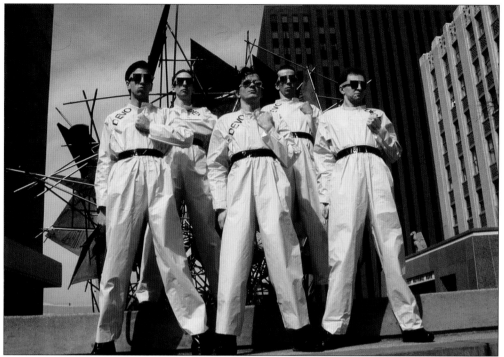

Devo was formed in Akron in 1972, and while it has had a few lineup changes over the years, the classic lineup consisted of Akronites Alan Meyers and Mothersbaugh brothers Mark and Bob. Pictured here in 1978 in downtown Akron with Kent natives Gerald and Bob Casale, the band's influence far surpasses what a group with one top-20 single should have. From left to right they are Bob Casale, Alan Myers, Mark Mothersbaugh, Bob Mothersbaugh, and Jerry Casale. (Photograph by Janet Mocaska.)

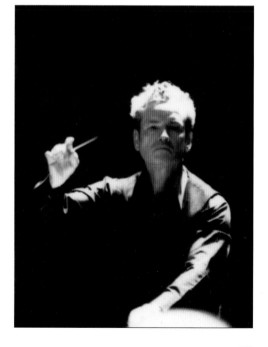

Classical music in Akron and Louis Lane are somewhat synonymous. Lane arrived in northeast Ohio and the Cleveland Orchestra in 1947. In 1955, he became assistant conductor to George Szell, the longtime conductor of the Cleveland Orchestra. He became the music director of the Akron Symphony Orchestra in 1959, just seven years after its debut, and remained its director until 1983. During most of his tenure, from 1969 to 1983, he was also a professor at the University of Akron. Also, while in Akron, he held positions with the Cleveland Orchestra, Lake Erie Opera Company, Dallas Symphony, Atlanta Symphony Orchestra, National Symphony Orchestra of the South African Broadcasting Corporation, and the University of Cincinnati. As of 2015, Louis Lane maintains a role at the Akron Symphony Orchestra as the conductor emeritus. (Photograph by Ott Gangl.)

Jane Ashley, who performed under the name Jane Aire, was a participant in the now-legendary music scene of late 1970s and early 1980s Akron. Supposedly, she was discovered singing along with a jukebox in an Akron café by Liam Sternberg, who also became a member of Jane Aire and the Belvederes. Sternberg produced *The Akron Compilation* album for Stiff Records that brought national attention to the Akron scene. Later, Sternberg found success writing and producing hits such as the Bangles' "Walk Like an Egyptian" and composing the scores for television shows such as *21 Jump Street*. Aire toured in the United Kingdom for a while and eventually married a member of the Boomtown Rats. (Photograph by Ott Gangl.)

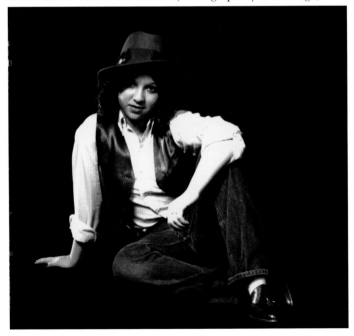

Rachel Sweet was never really part of the Akron music scene that took place downtown in the late 1970s, but she did appear on *The Akron Compilation* in 1978 and was produced by Liam Sternberg. She did manage a top-40 single in the early 1980s. Since then, while occasionally doing soundtrack work, Sweet has focused on acting, producing, and writing. Most recently she has been the co-executive producer of *Hot in Cleveland*. (Photograph by Ott Gangl.)

Klaus Nomi was a German-born performer known for his unusual appearance, operatic voice, and unique stage shoes. In the summer of 1980, Klaus and a fellow performer came to Akron after being invited by local band Chi-Pig. Klaus made an appearance during a show by Chi-Pig and Hammer Damage at the Band on South Main Street. During his time in Akron, he visited Stan Hywet Hall and a number of local business, which spurred the *Akron Beacon Journal* to do a cover story in its Sunday magazine titled, "This Guy Thinks Akron Is Pretty Unusual." (Photograph by Ott Gangl.)

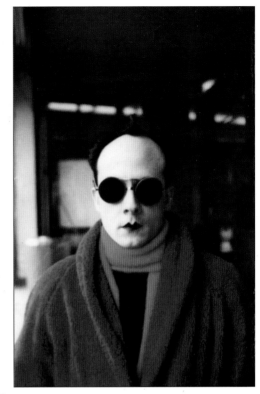

Rock 'n' roll hall of famer Chrissie Hynde was born and raised in Akron and graduated from Firestone High School on the west side of town. While in college at Kent State University, about 20 minutes from Akron, she was in a band with future Devo leader Mark Mothersbaugh. In 1973, she moved to London and five years later formed the Pretenders. In 1971, when this photograph was taken, she was already planning on being a star. (Photograph by Ott Gangl.)

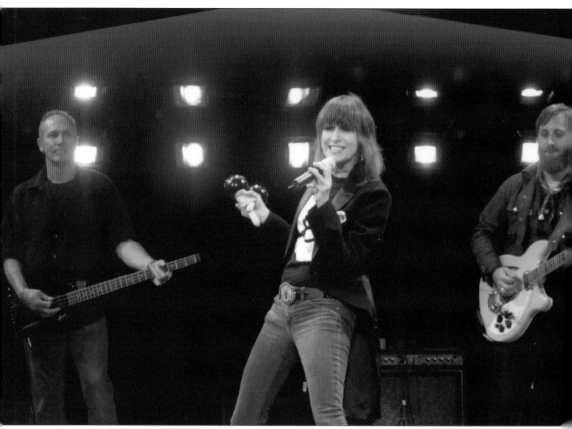

Hynde has stayed connected to Akron, opening the VegiTerranean, a vegan restaurant, in 2007. She performed three songs at the restaurant's opening, along with Pretenders lead guitarist Adam Seymour. Although the restaurant was well reviewed and rated one of the top five vegan restaurants in the country in some publications, it closed in 2011. Here, with The Black Keys Dan Auerbach (right), Hynde performs in Akron in 2008. (Photograph by Bruce Ford.)

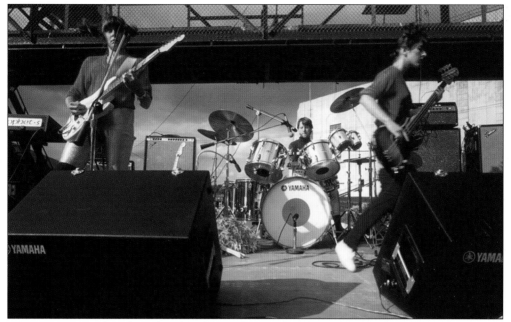

In 1977, Susan Schmidt and Deborah Smith joined with drummer Richard Roberts to form Chi-Pig. They took their name from a local barbecue restaurant that featured both chicken and pork. Chi-Pig appeared on *The Akron Compilation* album. Even though they had a song on the album and also released a single in 1978, they were unable to sign a record deal. (Photograph by Andrew Cahan.)

Chi-Pig did record an album in 1982 but broke up without releasing it. The album, *Miami*, was finally released in 2004. Chi-Pig was a mainstay at the Bank, pictured here, and invited Klaus Nomi to town. (Courtesy of Jimmy Imij.)

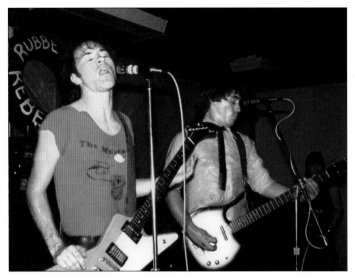

The Rubber City Rebels were a proto-punk band that was formed in 1976, coming out of another Akron band, King Cobra. They opened and ran the legendary Akron punk club the Crypt, at the time the only punk club in the Midwest, while also touring. In 1977, they opened for the Dead Boys at the legendary New York City club CBGB and released a split album with the Bizarros, titled *From Akron*. (Photograph by Sherry Rose.)

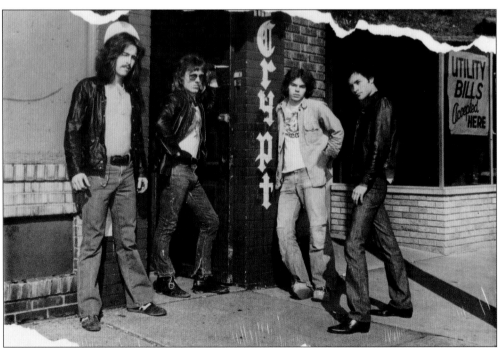

In 1978, the classic Rubber City Rebels lineup Akronites remember of Rod Firestone, Buzz Clic, Mike Hammer, and Donny Damage moved to Los Angeles and established themselves playing on Sunset Strip at clubs such as the Whiskey a Go-Go. In 1980, they released the eponymous *Rubber City Rebels* through Capital Records, without Hammer and Damage, who had left to form Hammer Damage. Despite excellent reviews and an appearance in the 1982 movie *The Assassination Game*, album sales did not vault them to the next level. They re-formed in the 1990s with Hammer and Damage and will still perform from time to time. (Courtesy of Jimmi Imij.)

Tin Huey took a backseat to nobody during the
mid- to late 1970s during the experimental punk
New Wave phenomenon that took over Akron's
scene. Their music was unique, perhaps too much
so to be commercial. The classic lineup of the band
included Harvey Gold, Ralph Carney, Chris Butler,
Stuart Austin, Mark Price, and Michael Aylward.
Gold on guitar and Austin on drums perform
here at the legendary Bank shortly after their
debut album, *Contents Dislodged During Shipment*,
was released. (Photograph by Rick Peters.)

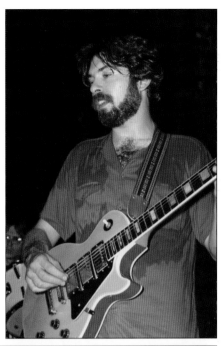

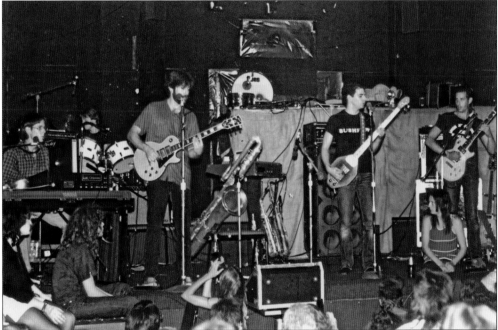

While Tin Huey never achieved the commercial success their original sound might have suggested
they deserved, individually and collectively they have done well. The band itself released three
more albums between 1999 and 2009. Butler achieved fame leading another Akron band, The
Waitresses, and as a producer. Gold Teleproductions produced numerous television shows for
several networks, at one time using Butler and Carney, who has worked with many musicians
but is primarily known for his association with Tom Waits, as one of the show's house bands.
(Photograph by Rick Peters.)

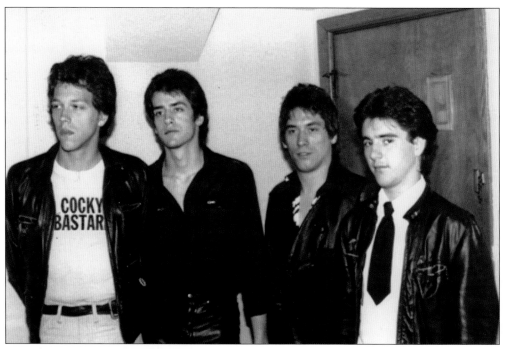

Hammer Damage was formed in 1978 after Mike Hammer and Danny Damage left the Rubber City Rebels. They built a strong following around northeast Ohio and served as the opening band for the Dead Boys, Public Image Ltd., and the B-52's. (Photograph by Sherry Rose.)

Donny Damage proved to be an able front man for Hammer Damage, and the band still plays packed reunion shows around town every now and then. They were also one of the three bands profiled in *If You're Not Dead, Play*, a 2005 PBS documentary. (Photograph by Sherry Rose.)

The Bizarros formed in 1976 and were one of the bands that performed at the Crypt, the first of the two legendary Akron punk bars. They appeared on a number of split albums and compilations before putting out their own releases. Since the 1970s, they put out one album in 2003 and have performed around Akron, always to enthusiastic crowds. (Courtesy of Jimi Imij.)

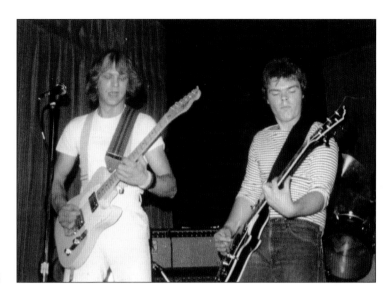

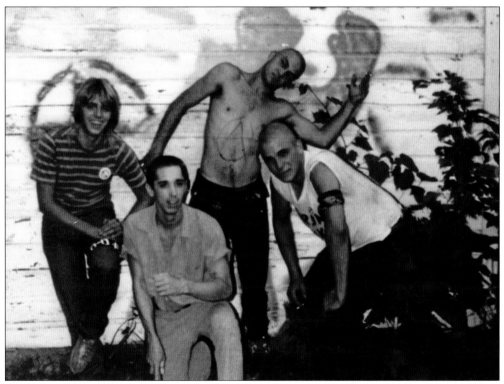

ODFX formed in 1981 as a hardcore punk band, coming together from other local groups. They originally dissolved in 1983, although they have reunited several times for live shows and to write and record new music. Bassist Brad Warner produced the documentary *Cleveland Screaming* in 2007 about the NEOhio punk scene in the 1980s, and Jimi Imij is the de-facto archivist for the Akron music scene. (Courtesy of Jimi Imij.)

If These Trees Could Talk is a post-rock band from Akron. The band self-released their self-titled debut in 2006, and it proved so popular that independent record label the Mylene Sheath chose it as its first release. Since then, the band has released two more albums and announced in December 2014 that another was due in the fall/winter of 2015. While the band's success has allowed them to tour Europe, they still perform in the Akron area. (Photograph by Sandra Kelly at NEMeadows Studio.)

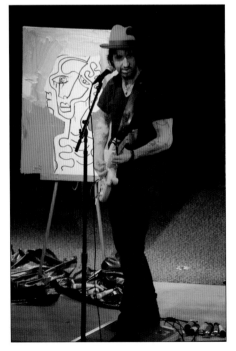

Before Joseph Arthur was discovered by Peter Gabriel in the mid-1990s and became a critically acclaimed singer-songwriter with a string of successful albums, he was an Akron teenager playing bass in a local blues band, Frankie Starr and the Chill Factor. A Firestone graduate, he moved to Atlanta in the early 1990s and has become an acclaimed painter and designer as well as musician. In 1999, he received a Grammy nomination for his sleeve design of his EP *Vacancy*. Arthur is pictured here performing at the Tangier, which has hosted live shows in Akron since 1949. (Photograph by Ad O'Hara/Sisters Dissonance.)

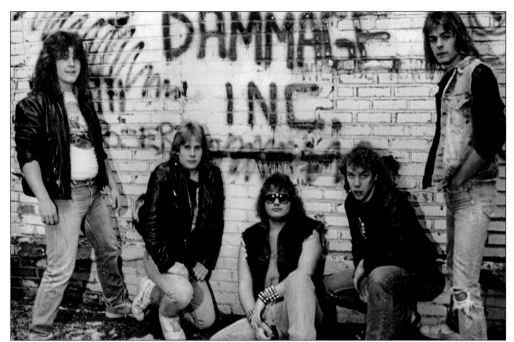

Grammy-nominated rock singer Tim "Ripper" Owens (center) fronted bands around Akron for most of the 1990s before leaving town to become the lead singer of Judas Priest, Iced Earth, and Yngwie Malmsteen's Rising Force. Owens also performs as a solo artist. He is pictured here with the band Damage Inc. in 1986, the northeast Ohio band he started singing with when he was only 18 years old. (Courtesy of Tim "Ripper" Owens.)

Owens has always stayed true to his Akron roots. He first opened Ripper Owens' Tap House in the Firestone Park neighborhood and now owns Tim Owens' Traveler's Tavern (formerly Ripper's Rock House), a rocking sports eatery, restaurant, and entertainment venue in the Kenmore neighborhood. While not on tour, Owens will play at Rippers, still delighting Akron crowds close to 30 years into his career. (Courtesy of Tim "Ripper" Owens.)

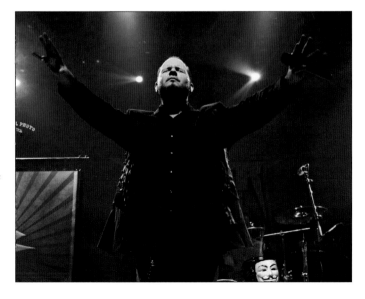

The most widely known band from Akron as of this writing is The Black Keys. Formed in 2001, they are shown here at the Lime Spider in 2005. They have pedigrees deeply entrenched in the Akron sound: Dan Auerbach was the cousin of Lou Reed guitarist Robert Quine, and Pat Carney is the nephew of Tin Huey and Tom Waits saxophone player Ralph Carney. (Photograph by Brad Lentz.)

They started playing around town0, with their first gig at Cleveland's Beachland Ballroom and Tavern drawing eight people. By 2003, they were stars and playing before far more than eight people. (Courtesy of Bruce Ford.)

Seven

THE UNIVERSITY AND EVERYTHING ELSE

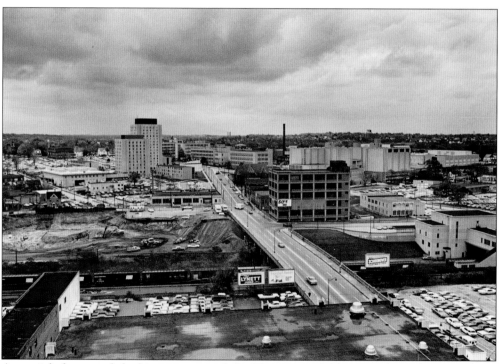

An aerial photograph looking east toward the University of Akron in the early 1960s shows how much the downtown and university area would be changing over the next few decades. The construction site was where E.J. Thomas Hall, named after a chairman and chief executive officer of the Goodyear Tire and Rubber Company, would open in 1973. (Courtesy of the *Akron Beacon Journal.*)

The region is infamous for the Kent State University tragedy of May 4, 1970. What is somewhat forgotten are the protests that occurred at the University in Akron, whose campus is less than 20 minutes from Kent State. More than 500 gathered at Buchtel Hall, peacefully, to hear speeches and demand the university shut down out of deference to the four KSU students who died. The protest was nonviolent, but tense, according to some student leaders. University officials complied, and the university was closed for the rest of the week. (Courtesy of the *Akron Beacon Journal*.)

When Bierce Library at the University of Akron was dedicated on September 19, 1973, this advertising supplement was placed in the *Akron Beacon Journal* to celebrate the event. It included photographs of the library, a description of some of the collections, floor plans, information about the people who designed the building, and a history of the library. (Courtesy of the *Akron Beacon Journal*.)

In 1989, employees of Akron's North Hill Marble and Granit Company erected a statue of the university's founder, John Buchtel, on campus. The statue was a copy of one that exists in the Glendale Cemetery, located on the west side of Akron, where Buchtel is buried. (Photograph by Ed Suba Jr.)

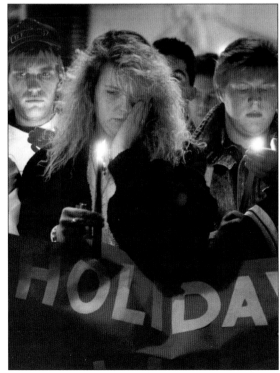

On Pearl Harbor Day, December 7, 1990, University of Akron students from Gallucci Hall participated in a candlelight vigil for troops stationed overseas in the first Gulf War. The sign in front of the students expresses holiday wishes to the troops. There were 465 students from Gallucci Hall in attendance. (Photograph by Robin Witek.)

Lee Jackson Track & Field Complex is known as a fast track. This became particularly true after the facility underwent $150,000 in renovations prior to hosting the Mid-American Conference Men's and Women's Track and Field Championship in 1998. The Zips' eight-lane, 400-meter Rekortan Surface was widened. Also, a new javelin runway, shot put sector, long-jump pit, pole-vault box, and hammer and discus cages were created. Pictured here is a competition from the 2014 Gay Games. (Photograph by Kelly Murphy-Stevens.)

In 2015, the University of Akron was offering approximately 200 undergraduate and 100 graduate degrees to over 27,000 students. Best known for its College of Polymer Science and Polymer Engineering, it has several highly ranked programs. Over the years, the campus has grown to cover 222 acres east of downtown. (Courtesy of the University of Akron.)

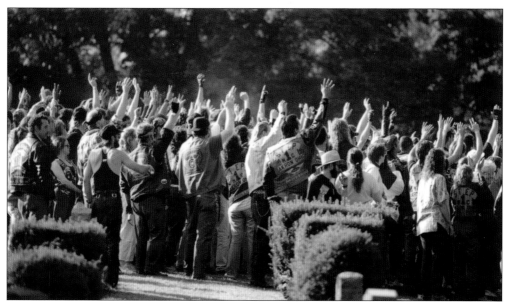

Members of Alcoholics Anonymous raise their hands in tribute to Dr. Bob Smith, cofounder of AA, during a 1993 memorial service at his grave in Mount Peace Cemetery in Akron. Thousands came to Akron for the ceremony. Dr. Smith's home on Ardmore Avenue in Akron is set aside as a museum honoring him as one of the founders of AA. It was named a National Historic Landmark in 2012. (Photograph by Kevin Casey.)

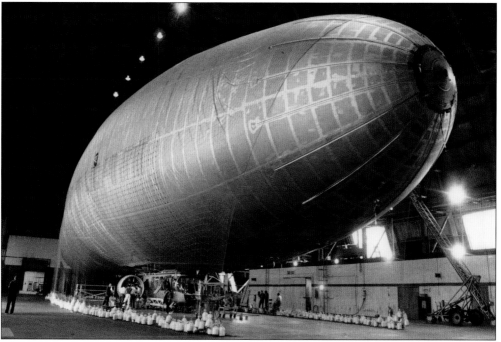

The *Akron*, a 206-foot-long blimp, is pictured filled with helium and ready to be christened in 1987 at the Wingfoot Lake Hangar in Suffield Township. It was the first time a blimp had been christened in the Akron area since 1969, when a 192-foot-long blimp was dubbed the *America*. (Photograph by Robin Witek.)

Fred W. Albrecht founded the Acme chain of grocery stores in 1891. By the 1930s, Acme had grown to 130 small neighborhood stores and was firmly entrenched in the community. Fred I. Albrecht, the grandson of his predecessor and president of the chain from the late 1950s to the early 1980s, guided the company into the modern era by utilizing the newest trends and technologies to transform Acme into a modern grocery store. Fred's son Steve succeeded him, and his grandsons currently hold top management positions within the business. (Photograph by Ott Gangl.)

Over the years, the Acme Fresh Market chain has owned, or co-owned, other chains in the Akron area. These include Clicks retail stores and Y-Mart Pharmacy and Convenience stores. Both chains existed from the 1960s to the 1990s. Acme Fresh Markets, like this one on Market Street in Akron, highlight their connection to the neighborhood by naming the aisles after local streets. (Photograph by the author.)